HOW TO TAKE ACTION PHOTOGRAPHS

How to Take action Photographs

THE RIGHT WAY TO PHOTOGRAPH ANIMALS, CHILDREN, NATURE, AND SPORTS.

by CHARLES SELF

DOLPHIN BOOKS
DOUBLEDAY & COMPANY, INC.
GARDEN CITY, NEW YORK
1975

LIBRARY OF CONGRESS CATALOGING IN PUBLICATION DATA
SELF, CHARLES
HOW TO TAKE ACTION PHOTOGRAPHS.
1. PHOTOGRAPHY, INSTANTANEOUS. I. TITLE.
TR592.S4 770'.28
ISBN 0-385-01285-3
LIBRARY OF CONGRESS CATALOG CARD NUMBER 75–24930
DOLPHIN BOOKS ORIGINAL EDITION: 1975
FIRST EDITION
BOOK DESIGN BY BENTE HAMANN

TO EDNA, FAITH AND CAROLINE,
THE ONES WHO GAVE ME A START
AND KEEP ME GOING.

CONTENTS

HOW TO TAKE ACTION PHOTOGRAPHS

1.

What Is Action Photography?

Action photography jams the excitement of the event underway right on top of the thrill of taking exciting pictures. Great shots of football linemen leveling opponents, cars skittering through curves at tremendous velocity, motorcycles leaping around a motocross course, all bring to mind the actual feel of the event as it really happened.

Many amateur photographers tend to shy away from action and sports photography as a too difficult part of their hobby, requiring a lot of experience or training and a huge amount of special equipment. A quick look at the pros who abound at various events will support the difficulty thesis, as well as the idea that a lot of gear is needed. These pros will be festooned with cameras, hanging from their necks and from their shoulders, and occasionally with one in a hand. Meters will dangle and lenses clank. The person underneath could be naked, for all any onlookers could tell.

In most cases, every piece of equipment a good professional photographer lugs about will have a use on the particular assignment he's trying to complete. For the truly dedicated pro shutter-snapper, the expenditure of over $5,000 on equipment in a relatively short period of time is very likely. It's also not really out of line if your regular eating habits depend largely on making sure you bring home good shots of fast-moving action, good enough to beat out the competition in this highly competitive field. Still, most of the shots we see in publications were taken with a basic array

of equipment, usually consisting of a camera and two or three lenses. If your personal ideal doesn't lead you into trick shots requiring such things as sliding zoom lenses and stroboscopic lights, the basic gear will be all you'll ever need, and very often you can get fine pictures with a moderately priced camera and no extra gear at all.

Even the price of a basic system camera can drive a novice out of the field. Of the five true system cameras now available, the cheapest retails for about $500, while the most expensive won't come into your hands for less than $1,000! That's for 35mm. Moving into the larger formats, the roll-film cameras that use 120 and 220 film, prices go up sharply, with most top-of-the-line models costing upwards of a thousand bucks. But there are literally dozens of good, relatively inexpensive cameras to be had, both new and used, that will do everything you will ever want to do and then some. And the prices can be held down to a modest fraction of the cost of professional system cameras, possibly even as low as $100, and occasionally a bit less with luck, shopping and bargaining ability.

Later on, we'll discuss the real needs in a camera for action photography, taking a look at why the most expensive ones can be a bargain for some people and a total waste of large sums of cash for others. It should be evident, though, how easily a pro— even considering the likelihood of discounts up to 30 per cent below retail—can spend as much as, or more than, five of the large treasury notes on equipment. Three camera bodies, two or three wide-angle lenses, three or four telephoto lenses, a zoom or two, a motor drive or two, possibly even a bulk filmpack, not to mention flash equipment, meters and so on. Good-bye, dream house!

You should be able to imitate the pro's pictures for less than one twentieth of that outlay. In most cases, with a bit of looking and compromise, you can put together your three-lens 35mm outfit for under $300, and going to used equipment will bring the price down even further or upgrade the quality of the equipment. It's even possible to ignore the basic three-lens-and-camera outfit and stay with your normal lens (about 50mm focal length) for many types of action photography. Naturally, this cuts your starting costs even more. We'll take a look at all of these later on.

Action photography is often thought of as sports photography, and that's frequently true. But real action photography can take place anywhere there's movement. The definition of action photography is still rather vague, but certain generalizations are safe. If you can shoot it with your normal camera lens, slow film, and a shutter speed of 1/60 second, it ain't likely to be action. The photo may be great, but the action won't be there. If you shoot the same scene, at 1/15 second, with the same film, but must use a technique such as panning to get a meaningful image, then it probably is action.

Many types of action photography have little or nothing to do with sports. You can be clicking away at birds on the wing, horses prancing in an open meadow, cats playing, children tossing sticks to a dog—almost anything that moves and captures your interest as a photography nut. Some of the non-sports types of action photography take more skill, luck and patience than any sports photograph ever can.

Serendipity is possibly the most important ingredient of action photography. If you're not there with your camera ready to go, that fortunate accident of fate can never happen to you. Patience is next in line, but only back by a millimeter or so. Follow that with technique, and then start thinking about your equipment. Good professional photographers try to have the proper equipment for any job they can reasonably expect to come in over the transom. Again, though, most of the work will get done with the basic stuff, not the exotica. Learning to use your basic camera is, or should be, the most important goal in readying yourself for action.

Judgment on the part of the photographer is essential for good action photography. As simple and easy to use as most of the techniques are, you must get the feel of the event yourself to be able to pass it on to others in photographs. You should know, and preferably enjoy, the event(s) or the people your film is being expended on. The resulting photos will be much better for your feeling, giving you more pride in your home displays, whether slide show or mounted prints, and making for more and easier sales, if that's your ultimate desire.

When mechanical objects are involved—cars, motorcycles, boats, bicycles or whatever—you'll often find it helps to supply

some aid to the feel of action as it appears, or will appear, in the final print. Boats can easily run just the opposite, though. Consider a large or small sailboat in a high wind. The boat is really hiked over, the crew strains over the side to keep it from capsizing or spilling the wind, the waves chop all around. What more does the photo need? Canoes in white water, speedboats suspended between waves, while trailing a shower of spray, offer the same built-in feel of action.

For some people sports offer the same feel of action, while others don't. Track-and-field events give you the chance to move in close and get the straining muscles and the agony expressed on a runner's face. Sharp, detailed photographs are excellent here, as are shots of basketball players going to the hoop, showing the tension in the body muscles and their suspension off the floor of the arena.

Action photographs retain all the values of composition, sharpness and shadow values that make photographs either good, great or lousy. The action photograph goes a bit further by attempting to present action which seems to be still taking place in the final photograph. Anyone can use an extremely high shutter speed to stop any action. My 35mm single-lens reflex has a stop speed of 1/2000 of a second; held at the proper angle, it will stop a speeding bullet, with no help from an ultra-high-speed flash unit. I've used it only a few times. To shoot a motorcycle slamming down a straight on a road-race course so that even the spokes are sharply defined defeats the purpose of action photography, because it eliminates almost all of the tension which must be captured to give the picture that action "feel." Even though the bike might be doing 150 or 160 miles per hour, it will appear, in the final print, to have been standing still or barely moving when the photo was snapped, if too high a shutter speed is used. This is a case where the mechanical object needs some help from techniques available to the photographer to prevent loss of tension in the action. While the photograph will retain some of the tension from the rider's body lines, the feel of speed is lost, thus the feel of risk is lost and—phffft! There goes most of the "action" in the resulting print. Using a shutter speed of 1/60 second and a special technique or two can keep that feel of risk—in fact, can even add to it, enhancing the tension and the feel of action in the final print.

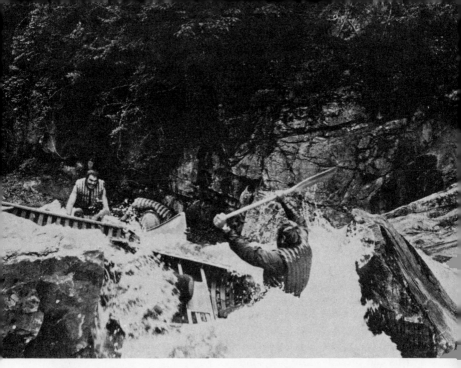

Figure 1. Though this photo was taken on a movie set, it shows the type of action which can be captured during canoe or other river races through white water. Photo from *Deliverance,* starring Jon Voight and Burt Reynolds, COURTESY OF WARNER BROS.

As we mentioned earlier, good judgment on the part of the photographer is essential, and judgment will improve with practice. After all, you can't make any sort of judgment as to how a print will look if you've never seen any prints. It will be necessary to shoot several rolls of film to see just how your camera reacts, how you react, and so on.

Rodeo is an example of a judgment sport. Some of the activities, such as bull riding, are best shot at high speeds. Here the muscular tension of the bull and rider, the probable levitation of the animal and rider in at least one photo, will convey all the feel of action you'll ever need in your final print. But barrel racing can be done both ways. Catching the rider rounding one of the barrels, with the horse and rider straining into the turn, is a good spot for a

high shutter speed (it can also be very effectively photographed with a low shutter speed and panning, or peak-action techniques). Low shutter speeds and panning present better results when the horse and rider make the turn and head for the finish line.

Children and pets provide some of the best opportunities for action photography, and again judgment is required. Do you want to catch the blur of a hummingbird's wings? Or would you rather have each wing outlined sharply as the bird hangs suspended before a flower or feeding tube? Catching children at play is one of the greatest pleasures of action photography, even though it presents special problems. Too often an adult can mess up the patterns of play and ruin the resulting shots, so a certain amount of psychology must be used, particularly with children who are not used to your presence. You want to catch the spontaneity, the sheer exuberance. This can sometimes be done by intent, even by asking the child to pose and enact scenes, but these little actors can often run away with things. Most children turn into incredible hams when faced with a camera for long periods of time, and this can present more problems.

Problems of judgment, of course. But further problems also if you do not know your camera thoroughly before starting to shoot, since you won't have much time to decide on techniques and adjustments in advance.

As you see, much more really depends on the photographer than on the equipment. The purpose of this book is to pass on the information I've managed to gather in some seven or eight years of action photography for a variety of magazines, with thanks to the editors who have helped from time to time to correct any technical faults that appeared. A photographer does well if he does not repeat the same mistake twice, or at least too many times, for this simple pastime can also become incredibly complex. There are plenty of new mistakes to make, so discard those old ones!

A good way to track down and then bury the old errors is to keep tabs on as much of the film you shoot as you possibly can. A small notebook and a pencil stub tied to it are ideal for this purpose. Write down immediately any goofs you *know* you made. Otherwise, just technical information (date, lens opening, shutter

speed, film type, etc.), plus a note or two to yourself. You won't be able to do this for every frame, nor would you want to, but a general notebook on tech data, shooting conditions, and any other pertinent information can be a help over the long run.

In general, the aim of this book is to show you some mistakes not to make at the outset, making the learning process a bit shorter and, hopefully, simpler. The methods presented here are not the only ones possible when you want good results (well, a few of them are, but not all, and most techniques can be varied to fit different circumstances). They work for me, however, and for many others. Modification, experimentation, different tastes in results, all are part of the overwhelming charm of photography as a hobby—and as a profession.

You won't find any darkroom data here, nor will you find ultra-sophisticated setups for stroboscopic photographs of a speeding bullet. There are dozens of fine books on the art and science of producing good prints, and the speeding-bullet and spreading-splash photos seem to have had their brief day, thank heavens. Here you'll find techniques and equipment suggestions which should help you get some "keepers" of your favorite sports, pets and people in action. And you'll be able to use equipment available to everyone at moderate to low cost.

2.

Your Camera

Today's miniature, subminiature and roll-film camera array surpasses all bounds, including those of good sense. Prices range from as little as $15 on up past the $1,300 mark, and styles are even more divergent.

For any person interested in action photography, there is at least one camera, and probably closer to a dozen, to suit the needs and budget. Compromises may be necessary, either in the camera or the price you are willing to pay, but the camera is the single most important piece of gear you'll buy for your photography, action or otherwise, and it's also very likely to be the most expensive, so in this chapter we'll take a quick look at a few cameras. Please remember, though, that good photographs are entirely possible—in fact, probable—with the cheaper cameras to be found on every dealer's shelf. Of course, much will depend on the size of the final print you wish to make (in general, the smaller the camera the smaller the possible final print, and the cheaper the camera the smaller the possible final print). Forget the bottom-of-the-line cameras—those selling for $15 or so. They're okay for kids to waste film with and for the adult who gets a kick out of any kind of image, blurry or otherwise. Expect to spend not less than $100 for the camera and a single lens; and, if you can, be prepared to spend $225 to $250 or more. The results will be well worth it.

Today, you can buy a half-frame 35mm camera; a Kodak Pocket Instamatic, or any of its legion of imitators; the original

Instamatic and its host of emulators; a full-frame 35mm camera in two basic styles and from many manufacturers; and 120 and 220 roll-film cameras that give large negative areas with a half dozen or more size variations. Then, the Polaroid line drops its size on you, with the newest addition, the SX-70, capable of taking one picture every one and one half seconds as the prints develop outside the camera.

Starting at the bottom, let's first take a look at the small negative sizes such as the Kodak 110 and the half-frame 35mm cameras. For the average snapshooter, the 110 camera is a real boon, but for true action photography it is severely limited. First, the rangefinder is tiny, making framing and focusing very difficult. Second, there's no way, at least at present, to change lenses, so you're stuck with the normal lens. Then, the winding of the camera takes two and one half strokes, slowing up response when the action is hot and heavy. The ultra-light weight makes the camera much too prone to shake as compared to heavier 35s, especially considering the minuscule negative size. Any enlargement at all tends to emphasize blur over all else. Not the camera to use after a night on the town. When all these drawbacks are added up, the person trying for a shot or two of a careening figure or vehicle is in for a hard time.

For most general photography and snapshots, the 110s are nearly perfect, because of their light weight and ease of handling. For other uses, however, such as high-speed action and controlled shooting (most 110s have electronic shutters which present you with no data and little or no override opportunity), they are better left at home. If you have one and wish to practice with it, great. If you can get even mediocre action shots with a 110, then you should be a whiz with a 35mm or larger-format camera.

Generally, 35mm half-frame cameras offer a flatter film plane than the 110s, with a camera that's much heavier. Interchangeable lenses are available, as are other accessories, but the choice of brands almost begins and ends with the Olympus Pen FT. Basic advantage: as many as 72 shots on a 36-exposure roll of 35mm film. Basic disadvantage: image area on film which prevents real magnification, though the very careful photographer can do wonders with half-frame cameras.

When you move up to the full-sized 35mm camera, you'll feel

much like Alice in Wonderland: confused. There's a two-way division of cameras, the rangefinder and the single-lens reflex (SLR). There is also an ongoing argument as to which is better for most types of photography, but for our purposes the argument doesn't exist. The only rangefinder camera generally available that offers all the features needed to produce good action photos consistently is the Leica M5. As far as I know, this is the only rangefinder offering true lens interchangeability. Focusing at low light levels is easier and the rangefinder is quieter, since there's no mirror to be raised and dropped as the shutter clicks. Usually a rangefinder will also be a bit lighter than a comparable SLR, though not really enough to make much difference. When the advantages and disadvantages are dropped in a bucket, the first thing that floats to the top is the Leica M5 retail price of about a grand and a quarter! For a camera that has difficulty in accepting really long lenses, this is an awful lot of cash. And any extra lenses will tend to cost in proportion to the cost of the camera, which can aid the knees in developing a rubbery feeling.

From the rangefinder, it's but a short move to the most popular 35mm camera, the single-lens reflex. With an SLR, the photographer peers through a prism—the distinctive prism housing forms the top center of almost all SLR cameras—which works with a mirror to give a view through the lens. No rangefinders, viewing lenses (as in twin-lens reflexes) or anything. You see the image almost exactly as the lens sees it. Though a few of the cheap SLRs come with noninterchangeable lenses, almost all come with the option of using any of several dozen lenses made by the camera manufacturer or by independent lens makers such as Soligor, Tamron and Vivitar. Usually these independent lens makers will produce lenses with a quality of glass equal to that of the camera manufacturers, but with mounts that are not quite as precise as those made in camera factories (the same basic lens, with an adaptor, may fit a dozen or more brands and types of cameras). This often results in slightly lower overall quality in the negative. Then, again, the price of a lens from an independent maker is usually much lower than the price of a comparable lens from the camera maker. Or you may have a choice of lenses the camera maker doesn't offer—either in price range, speed, size, or all three.

Canon lenses tend to fit Canon products better than do, say, Miida lenses; Nikkor lenses, Nikon products, and so on. But you can often change the adaptor on an accessory lens for just a few dollars to fit it for a new camera, should you decide to switch brands at some point (almost everyone does, sooner or later). Canon, Nikon and Pentax provide unbeatable lens lines. Almost no one else does, so you may well have to go to an independent maker to find the lens you want.

Canon and Nikon have a wide line of accessories for a very simple reason. They are system cameras, designed for use by professional photographers. A system camera is one which the maker designed to accept a wide variety of lenses and accessories for maximum versatility. From a professional photographer's viewpoint, this saves in two ways: first, the need to have several different cameras for different jobs is lessened (though not eliminated); second, ease of use is increased, since overall familiarity with the basic camera can now be maintained on a day-to-day basis with just a single camera body. And it's usually cheaper.

If you're in the market for a camera, consider as many brands as possible and especially such brands as Alpa, Exakta, Fujica, GAF, Hanimex Praktica, Honeywell Pentax, Konica, Leicaflex (except for its exorbitant cost), Mamiya/Sekor, Minolta, Miranda, Olympus, Petri, Rolleiflex, Topcon and Yashica. Many of these are fine and deservedly popular instruments, and prices now start at under $250 and are often discounted to well under $200.

After you've decided just how far your wallet will stretch, it's time to strut out to the camera stores and start looking at some of these better cameras just to get an idea of what features are to be found in your price range. Minimum features for action photography are: lens interchangeability, a top shutter speed of at least 1/500 second, and a lens that opens up to $f/2.8$ or larger. A single-stroke wind lever is now standard on almost all 35mm cameras. Make sure you don't buy one of the few still around that need more than a single stroke, although a camera which allows you to take several short strokes *or* one long stroke can be handy at times. Through-the-lens metering is a nice feature, but requires some adaptation on the part of the photographer to make up for inherent problems. Any money saved could be invested in a good hand-held meter if you decide on a camera without a built-

in meter. No meter is perfect, so the choice is up to you, your budget and your photographic plans.

If your future plans include the use of ultra-long lenses, motor drives or other specialized accessories, be sure the camera you buy now can be adapted to accommodate all the things you'll want to add in the coming years. Or make certain that the lenses and other accessories you buy now can be transferred to a new camera body without major alterations. To date, only Canon, Nikon and Olympus offer cameras with accessory motor drives. Both Minolta and Topcon offer cameras with built-in motor drives.

The best advice is not to start at the top. You can't really know now just how long your interest in photography will last, though it seems very few photographers vanish totally from the scene. Sometimes our enthusiasm wanes, but then an event comes along that offers such great photo possibilities that the hands start to itch for the feel of a good camera, and that ends the ghosties for at least a time.

Not starting at the top would also give you the option of moving into the less expensive brands of cameras.

For those who don't wish to do anything more than focus and shoot, there are now a large number of automatic cameras that meter the scene, set the camera and leave the photographer with nothing to do except compose, focus and click the shutter. Unfortunately, all these cameras must operate from information fed into the system by the meter. Because no built-in meter is as good as a hand-held meter of comparable quality, this tends to present a few problems.

Meter quality, as the above statement indicates, is not always the determining factor in accurate readings. Meter movements become more accurate as they become larger, all else being equal; thus, a built-in meter with works no larger than a bottle-cap can't possibly be as accurate as a hand-held meter with works the size of a pack of super-king-size cigarettes. You have to get used to the meter. And you have to get used to those situations where light from one portion of the picture affects the light from another portion, so that the meter reading alone is not completely reliable. All good automatic cameras allow the photographer a large degree of control, and information on setting

shutter speeds and lens openings manually is provided, making it possible to switch over to manual and use methods learned from experience. For action photography, that's what you'll most likely have to do most of the time. Letting the camera select the shutter speed and/or lens opening makes panning, pre-focusing, close-up metering, advance metering and other action techniques difficult or impossible.

If you are looking for the convenience of an automatic for most types of photography, Argus/Cosina, Canon, Honeywell Pentax, Konica, Mamiya, Minolta, Miranda, Nikkormat, Petri, Ricoh, Topcon and Yashica turn out fine cameras with automation. However, for action remember that you'll want to switch to manual control. Make sure it's available.

Quality in camera construction is of concern to every photographer, whether the camera is used for one quick series of holiday or family snapshots or hundreds of rolls of film over the year. The differences in quality needs, though, should be obvious. The pro who is pounding his camera, clicking off shot after shot through as many as forty rolls in a single day—my own personal high—can expect *no* camera to last too long. The Christmas snapshooter will have more of a problem from internal dust accumulation than from any real wear and tear on the camera or lens. If you don't honestly evaluate the uses to which your camera and related accessories will be put, it's all too easy to find yourself dropping well over a thousand bucks for the camera body and a medium telephoto lens. If you do evaluate carefully, and don't use the camera too severely, you can probably put together the same outfit for less than a third of that amount. I don't know about you, but spending sums as much as $700 unnecessarily makes me exceptionally nervous.

Primarily, a higher-priced camera will offer heavier construction, better-cut (more precisely cut) internal gears of better-quality materials, a more accurate shutter and a better lens. Added to this will be a heavier, flatter film-pressure plate, to aid in keeping your film flat during exposures, a prime requirement of overall print sharpness when all the work is done. The heavier construction can be essential to the working pro, but is often just expensive to the amateur.

Less espensive lenses and cameras often come very close to

matching the performance of the very expensive ones. Major differences are as likely to be in and around the internal parts (as far as weight and accuracy are concerned) as in the shutter mechanism and the grinding and compounding of the lens. Thus, while one company can sell an $f/4$ 200mm telephoto lens for under a hundred bucks, Canon's FD $f/4$ 200mm telephoto is going to cost at least three times that, even if you haggle the dealer down for a heavy discount. When you realize that you probably won't be able to tell the difference in your final prints, what's the benefit? Certainly the Canon lens will outlast the cheaper lens, by a factor of ten or more to one, under almost any conditions in which you use the two lenses, and it will just as certainly outperform the cheaper lens in tests for almost any good qualities you expect to find in a lens. But for the average non-professional photographer the hundred-buck lens is a much better buy simply because it will last for from five to ten years under normal conditions of use. For the pro who uses a 200mm extensively and hard, it's a waste of money, since it will probably fall apart in less than a year and will have been taking lousy pictures for half its useful life. Are you going to shoot more like the pro, or—truthfully, now—will you use the lens more like the average photographer, say once or twice every month or two? The difference, either way, can mean quite a cash saving.

When you start thinking of moving out of the 35mm camera field, into the world of larger negatives and transparencies, you begin to run into pricey equipment. Twin-lens-reflex (TLR) cameras have seen their heyday, and have been in a decline for many years now. I've got one for those magazine editors who once in a while insist on absolutely no negatives or transparencies under 2¼ inches square, but it seldom gets used, and it also is difficult to use for action photography.

The TLR, if used without special viewers, has to be sighted through what is called a sports finder. The sports finder is usually a square hole cut in the front-light hood section, or into a section that drops down in place of the front-light hood. Supposedly, action viewed through that hole will inch around to line up properly on your negative, but until you know that, you'd be wise to back up your shots, getting plenty of extras. Another severe problem with sports finders is the lack of focus capability once you're

ready to shoot. All works fine until a racer drifts out on a corner and takes a line just a hair too far out of your field of focus. The resultant shot can have beautiful action and color, but it will be fuzzy, fuzzy, fuzzy! Generally, the slowness of handling brought about by having to crank the film, cock the shutter, aim at waist level and pre-focus, flip up the sports finder and bring the camera to your eye, will drop the TLR rather low in the running for any kind of action photography. If you're willing to add some extra practice time and film to your normal needs, these inexpensive cameras will do the job.

Prices are pretty low. And you can buy accessory lenses which will clip or snap over your prime and focusing lenses to give you moderate wide-angle and telephoto capabilities at a modest loss in lens speed.

From this point, it's a reasonably short hop to 2¼ inches square, 6 cm. \times 7 cm. (2¼ inches \times 2¾ inches) and other film formats used in a large variety of cameras, both with and without eye-level viewing. Prices range upward from about $300 (which usually includes only the body and a normal lens, with no meter, no speed finder, nothing). From there, it's still a short hop over the grand mark for a naked camera body and lens. The excessive cost of these cameras, added to their extreme weight, make them a poor buy for most photographers. (You haven't really suffered until you've spent a day or two—or even six, as I did recently—with a Yashicamat, a Pentax 6\times7, and a Canon F1 dangling from your neck while hiking several miles back into muddy woods to cover an off-road motorcycle event.) The Canon F1 with normal lens weighs in at just about 2 pounds 9 ounces. The Pentax 6\times7 pulls your neck to the tune of 5 pounds 5 ounces! A few extra lenses, a meter or two, and a few thises and thats, and the weight really begins to become a problem with all larger-format cameras.

It must be admitted, here and elsewhere, that shadow detail and general sharpness are a great deal better with the roll-film cameras, assuming near equal lens quality and overall construction. That's why they're used as often as they are. For you, and for me in the future, the 35mm camera is nearly impossible to beat. You can find an absolutely shattering array of accessories, a fine line of lenses, and a camera body which will do just about any-

thing you ask of it, including giving you photos that can be enlarged to 16×20 inches if your picture-taking techniques are good. Posterizing to larger than 16×20 inches is also possible. So what else can you want?

My recommendation for a camera for general and action photography, then, becomes obvious. Look for a good-quality single-lens reflex—with the funny little housing on top—which accepts interchangeable lenses made in reasonable profusion for it, either by the camera maker himself or by one of the independent lens manufacturers such as Miida, Tamron, Soligor, Vivitar. This information is easiest to come by if you get your hands on a copy of the annual issue of either *Modern Photography* or *Popular Photography,* which lists nearly all the lenses made for every camera made. Remember also that back issues of these two magazines are probably stocked, for at least a year, in your local library.

Minimally, for a 35mm single-lens-reflex camera, you'll eventually want to add a 28mm wide-angle lens, a 50mm or 85mm lens for use as a normal lens, a 135mm lens for most sports photography (hockey, basketball, etc.), a 200mm lens for motor-racing photography, and a 300mm lens just for the hell of it. You can get started, I would think, with just the normal and either the 135mm or the 200mm, depending on the types of events you prefer to photograph. As cash becomes available, you can add the other lenses you still want.

A normal lens will do many things if you don't care to spread the wealth any more. Though it's not a wise procedure, I did get through nearly two seasons of motorcycle (motocross and enduro) photography with just a 50mm lens, though the resulting frights and incidents endeared me not at all to many of the big riders and a few other photographers. The big problem with such a short lens becomes most apparent at races where you have to get too close to the action, taking chances on getting hit or causing a rider to spill, while, at the same time, you're blocking out the shot chances of photographers who have the proper equipment. While it's not as bad as a 200mph front fender, a motorcycle handlebar at 40mph doesn't do even a wee bit to aid the digestion.

Choosing *your* camera is a relatively simple process. Check

the local camera stores, your friends' gadget bags and so on, for cameras in your price range. Then, when at all possible, spend some time handling the camera that looks best to you. Is the shutter release in easy range of your finger? Does the film-wind lever work easily for you—you don't care even a little bit how great or bad it feels for me, a tester for a photo magazine, your uncle Jack or anyone else! Is the image in the viewfinder clear and sharp, with or without eyeglasses? If you don't wear glasses, you're well ahead of the game, believe me. Is the apparent focus easy? I say "apparent focus," because you have to actually take some photos to find out just how accurately the camera is really focusing. Even with an SLR, it's possible to get good apparent focus and poor-to-fair real focus for a variety of reasons, paramount among which is a poorly designed or poorly manufactured film-pressure plate. If your film doesn't lie flat when the picture is taken, the greatest care in the world can't give you a sharp photograph. Now look to see if the focus and lens-opening rings on the lens barrel are easy to tell apart in handling. This may not seem of utmost importance, until you have to hop around quickly trying to focus without slipping the lens to the incorrect opening, or vice versa. Then you'll get an idea of how much time can be wasted if the rings are too hard to tell apart. Especially on a cold day when you're either wearing gloves or have severely chilled fingers.

Basically, the entire point of all these little tests and exercises is to find out if the camera feels reasonably comfortable to you. If it feels good when you're not used to it, just imagine how much easier the whole thing will become after you've spent a few hours practicing the various operations.

While you're at it, check the film take-up spool. This slotted spool can become extremely important if you're attempting to load film at a run or in a general hurry—for the person who anticipates having to load film at a run, the purchase of any camera with a removable back, such as the Nikon FTN, is a strict and flat no. Such backs get misplaced, require extra hands, get lost, get stepped on, sat on, dirty, muddy, and they waste time. Back to the take-up spool. The more slots the better, usually, since if you miss one, another will be there to receive the film end. Loading

is another point for which the 35mm camera receives better marks than any roll-film camera. All roll-film cameras require the photographer to remove a spool from one end of the film chamber and insert it in the other end before even attempting to slip in fresh film.

A final check might be given to the direction in which the spool winds the film. Some film-wind setups direct the film right over and around the spool, and this is best. The least desirable setup is one where the film revolves against its natural direction of curl and back toward the center of the camera. Such a requirement means that you have to be a great deal more careful when inserting the film tab in the take-up spool to prevent its being pulled out and the film from being transported.

If the camera that meets your desires costs too much for your budget to bear, there is another way to go. Buy a used camera. Multitudes of cameras are traded in for a variety of reasons every year. Some photographers are moving up to a fancier model, some are broke and need money, and some want to get rid of a lemon before it acts up again. Usually, a camera traded by someone in the first two categories will supply you with years and years of good service at a price way below that of a new camera. If you get stuck with a camera traded in by someone in the last category, ouch!

When searching out your slightly worn dream camera, talk to people in the business, people who can give you an idea of how sturdy a particular camera is. Most camera dealers will be reasonably honest about the strengths and weaknesses of equipment, if you give them a break and let them explain things first. Don't buy it, break it and come back raving. Talk to some advanced amateurs and pros, if possible, but discount at least 50 per cent of what you hear about any one brand being the absolute best or worst. Most of us tend to get hung up on the equipment we're using at the moment as long as it is giving satisfactory service, and we also tend to go completely insane when a particular make of camera gives us trouble.

Select the camera that fits your needs. Find one in a store or owned by an individual. Then check it over for general signs of wear and tear on the outside. A used camera from a professional

might look pretty ragged on the outside but still have lots of wear left on the inside, while an amateur's turn-in might look new outside and be mere junk internally.

Take the camera in your hands and go through the shutter speeds and lens openings, cocking and clicking at each opening. You won't get an accurate reading this way, but you'll at least find out if the shutter fires at all indicated speeds. Lens diaphragm openings can be checked for size by opening the back of the camera, setting it on ½ or 1 second and varying the lens openings as you click the shutter. Point the camera at a light wall for this check.

Make sure that all knobs and wheels turn as they're supposed to. Don't force anything if it won't work—just hand the camera back to the seller and continue your search.

Don't listen to any nonsense about a sticking mechanism, either on a new or used camera, working itself out as time passes. Your camera doesn't need a break-in period, and any sticking is a sign that something's wrong.

Place a sheet of white paper on a table or counter, open the camera back and gently shake it over the paper. If dirt drops out, resume your search for a camera.

Do the obvious checks, too. Make sure the lens isn't scratched. Look at the film plate inside the back of the camera and make sure there are no scratches or scrapes. Look for any signs that the camera has been dropped or hit hard in some way.

Now take the camera home and perform the checks we will outline in the following chapter. Taking the camera home, new or used, should entail no financial risk on your part. Whether you're planning to buy from a dealer or an individual, get a written return privilege for a specified number of days, weeks, or whatever. Make sure you've got time to run several rolls of film through the camera before the warranty period runs out: a minimum of two weeks, preferably a month. If the person selling the camera won't go for this, don't deal with him. He may not be a crook, but he thinks you're a fool!

You've bought your expensive new single-lens-reflex 35mm, you're all ready to start taking pictures, snapping away with the expectation that the new and better camera will take better photos

than you've ever taken before simply because it looks fancy and cost a bundle. Well, maybe. In most instances, any good camera will outperform the nut behind the viewfinder, but without proper technique the camera will have capabilities you'll never discover. In fact, an adjustable camera, regardless of cost, can hand you some of the worst pictures you've ever seen if you just hop right out and start trying to grab photos of a rider about to be spun off the back of a Brahma bull.

3.

Learning About Your Camera

For too many people today, photography has become a game of equipment. In many senses, it may well be true that a workman is only as good as his tools. This certainly holds true for photography to a large extent, for there are many things that require a certain type of equipment or a certain type of camera in order to produce a reasonably good photograph. Still, too much emphasis is being placed on the chunk of metal, plastic and glass you're holding in your hand. If equipment is so overwhelmingly important, it seems to me that Mathew Brady and all those photographers before him (along with quite a few who followed) would never have been able to take a single decent photograph, not to mention some of the really great ones that have lasted over the past century and more. The equipment used by older photographers, including many still alive and working, compared to what we have today, qualifies as unsophisticated at best and junk at worst. Nevertheless, they got the pictures. Why?

In some senses, photography is a true art form, though it often seems more automatic, more dependent on machinery, than any art form should. Still, in most cases it's the man or woman behind the camera who makes the picture, with minimal or no co-operation from the equipment. Basic technique is a good starting place for that sort of work. If you know your camera so well you can forget almost all of the actions required to load and operate it, then you're ready to start taking really good photographs, whether of action subjects or not. If you don't learn everything about the

camera, you may still get an occasional good shot, but don't expect to see consistently good results or you'll be sorely disappointed.

It's probably a fair assumption that you've been fiddling with that new camera ever since you took it out of the box. The "new toy" syndrome usually takes a few days to wear off, but it can be put to good use while it exists. Practice with new equipment is always more fun than practice with old equipment you already feel wedded—or welded—to. So, if you're going to buy a new camera in order to get started in action photography, the time to start practicing is now.

Take the camera out of its styrofoam and plastic bed and put it down. Pick up the most important single piece of photographic literature you'll ever have—the instruction booklet for your camera. Read that booklet thoroughly. When you read, as you read, handle your camera. When the book tells you a certain lever locks up the mirror for use with special lenses, try it. If the book tells you the camera body back is removable, take it off. Remove the lens and watch the shutter operate at slow and fast speeds. Examine the lens diaphragm, looking through it at a diffuse white light, and vary the lens openings. Try the depth-of-field indicator. Set and reset film-speed (ASA) markings, if the camera has an internal meter. Put it all together and practice focusing on different objects, trying first to judge their distance from the lens.

Do it all. Develop complete familiarity with your camera, even with operations you never expect to use. You've got to learn its total capabilities and become proficient in the operation of your equipment before you can add your skills in order to produce pleasing images of good quality.

Now comes the time. Load your first roll of film. Set the camera up properly. Start looking for subjects. As a suggestion, you might try this: find a newspaper with some moderate-to-large headlines, as well as some small type. Tape it to a flat wall. Making a note of your frame numbers, take a tape measure and start shooting pictures of that newspaper at varying distances, from as close as the lens will focus, to infinity if possible (use an outdoor wall if your home doesn't allow you enough room to focus at infinity). By doing this, several things can be checked. First and foremost, the focus of the camera (from about 18 inches to beyond 30

feet) with that particular lens. Repeat the test for every lens you buy or have. Checks should probably be made at five distances, though three might be enough. Vary your shutter speeds and lens openings at each distance, recording the data on a pad as you shoot. This will give an indication of overall sharpness at various lens openings—it will vary! If you have to drop your shutter speed under 1/250 second while shooting this test, use a tripod to minimize the effects of camera shake. Later on you can repeat the test at slow shutter speeds with no tripod to get an idea of just how steady you are, but first find out what sort of base you're working from.

When the film comes back from the processor—or from your darkroom, if you do your own work—use a magnifying glass to see just how sharp each image is. This test won't give you any laboratory proofs of lens sharpness or focus accuracy, but it will tell you the only things you really need to know: how well the camera works for you. You'll discover how sharp the camera is in your hands right at the start. From there, it's mostly a matter of improving a little at a time until your sharpness is as great as you want or are capable of producing. Of course, this test will also give strong indications of just how accurately your camera was adjusted at the factory. If everything is blurred, either you're messing things up badly, in which case a tripod and cable release must be used when the test is repeated, or the camera is a lemon and must go back to the dealer. A retest will show which problem is yours and give you a start on making corrections.

Test shots should be printed on single-weight glossy paper, no smaller than five by seven inches, and preferably at least eight by ten. Eleven by fourteen would be best, but that can get awfully expensive if you're not working in your own darkroom.

Now that you know the camera is all right, and you've gotten used to handling it loaded—another point of the foregoing check— the time has arrived to consider some tips that will give you better pictures almost every time. Please note that "almost," for the best photographers in the world make mistakes, usually quite silly and basic ones.

Not holding a camera steady when the shutter is activated probably causes more blur problems than any other single mistake. Many photographers claim to be able to get sharp photos

"every time" at ridiculously slow speeds, say as low as 1/15 second. Forget it! Look for reasonable sharpness most of the time at speeds as low as 1/30 second and use a tripod for the rest. These shutter speeds, by the way, are those that fit with a 50mm or 55mm (so-called normal) lens. Longer lenses will magnify the problems of camera shake, thus requiring higher shutter speeds. Shorter lenses don't do much to reduce that shake, though you are more likely to get usable photos at 1/15 second hand-held with a 28mm lens than you are with a 50mm or longer lens. Not much, though. For a 100mm or 85mm lens, the slowest practical speed is probably 1/60 second. For 135mm and 200mm lenses, try to make your minimum at least 1/125 second. A speed of 1/250 is even better with the 200mm. For lenses over 200mm, a tripod is almost essential, since the lens has reached a size and weight where the camera/lens unit is probably nearly doubled in weight and is very nose-heavy. Some hand-holding of the smallest (physically) 300s is possible, with best results likely at speeds of no less than 1/250 second and, ideally, at 1/500.

Camera steadiness can be increased greatly by proper holding and by using whatever props are available as steadiers. Normal shooting, from a standing position, is best carried out by bracing your feet slightly apart, making sure that you are comfortable. Doing a split doesn't increase one's steadiness at all! When practical, I use a stance that places one foot slightly ahead of the other. For my size and build, eighteen inches apart with a six-to-ten-inch setback on one foot seems to work best. Try various positions for yourself, for it's unlikely, even if you are of the same build and physical type as I, that your muscles would respond exactly as mine do. Since I'm righthanded, I much prefer to hold the camera with my right hand and make most adjustments with my left. Keeping the elbows close in against the body can help too. The right arm must be completely still when shooting, except for the finger which squeezes the shutter button. Complete (or as complete as humanly possible) stillness will show up in your photographs.

The camera should be handled in a way that allows your non-holding hand to focus, while the holding hand does the squeezing off when your picture is framed and ready to be snapped. Gently

press the camera back against your forehead. "Gentle" is the key word here. If you press the camera too hard in any way, your muscles will shake from the tension, causing camera shake. Firm, gentle handling is essential in all situations, even when a good stance isn't possible.

Actually, shooting the picture works best for me if I follow the admonitions of my Marine drill instructor. Squeeze. Don't grab or jerk. Take a breath and let half of it out, hold the rest and squeeze off the shot. Be it a rifle or a camera, the resulting steadiness is dramatic!

Odd spots will require odd stances. You may have to kneel, with the camera held so that one elbow rests on your knee. The best form here is to avoid the actual knee bone, which is a strong transmitter of body shake to the bony elbow resting on it. The elbow should be placed on the pad of muscle behind the knee, or the crooked elbow should be placed alongside the bent leg and pressed firmly in place. These two methods are much steadier, by the way, than the standing position.

A bit of practice on kneeling and standing positions will give you an idea of the degree of solidity you can expect from your body. Physical types can affect the result, as can overall physical condition. The short, stocky person will have a more solid platform than will someone who is tall and gangling, though proper technique can overcome most of the differences.

Each and every person will have to work out whatever variations of sitting and standing best suit him, so the above suggestions supply only the basic principles.

Extreme steadiness problems can result when using long lenses, as we've mentioned. There are several gadgets which can help to lessen the dread "tele tremor," and they will not financially strip you. For quick movement and ease of use, the monopod stands alone. A single leg stand, with a screw that fits into the tripod socket of your camera, the monopod usually comes in adjustable form, from about eighteen inches on up to six feet or more. For a 200mm or 300mm telephoto lens, these monopods are very handy. You'll find yourself squeezing off shots at half the shutter speeds you'd been able to use pre-mono. When a monopod or tripod can't be used or isn't available, a modified dog-chain gadget

can help. Some models have a loop at the end of a light chain, which is fine if the chain can be adjusted to fit properly. But the preferable model is totally free of such gewgaws. It is simply a four-foot chain. One end will have a tripod-socket screw. You just screw it in, drop the end and step on it. Pulling up and a bit back against the chain will firm up your camera hold quite well. (A piece of cord or light rope can be tied around the camera body if no chain type of holder is available.) Simple. Remember, though, that while the pull against the camera must be firm, gentleness is again the watchword. Too hard a pull will start the muscles shaking and defeat the purpose of the pull-pod.

You will now have steadily shot your way through all or most of your first and second rolls of film in your new camera. If the shooting doesn't finish up the roll and you decide to leave it in, use a piece of masking tape to mark the film type and date right on the camera: TX (or, as some people prefer, 3X or XXX) 3/14/19—. This keeps you from forgetting, first, the film speed, and, second, how long the film's been around. If you don't use the film in a reasonable length of time (depending on the use date on the film box), have it developed anyway. Otherwise, it can deteriorate and damage the images you've gone to a lot of trouble to capture.

As you get ready to load the next roll, make sure the film engages at the sprockets before you slam the door on it. For an even more certain indicator, flip up your rewind knob. As you wind the film forward, the open rewind knob will turn, proving that things are actually happening inside the box. Great embarrassment ensues when you carefully line up and shoot twenty or thirty views and get nothing at all back from the processing lab! Such mistakes happen to all of us, all too often, but care can eliminate this common goof.

Now check your light-meter battery, make sure the lens is bayoneted or screwed down securely and the camera back is up tight. Look at the front of the lens to make sure you haven't left a filter on—with a single-lens-reflex camera, you won't try to shoot with the lens cap on, since you can't see a thing that way, but filters can be left on and forgotten. The lighter tints may not show up in time to prevent the loss of several shots or even a roll of film or two.

Generally, the above checks should be done each time the camera is readied for use. Obviously, there's no need to make these checks each time you run a roll through the camera, if all is done at the start of the session and you keep right on shooting.

For normal photographs, the above tips should help you to get consistently good results.

4.

Action Techniques

Normal snapshooting is what you've been getting into up until now. From this point on, you'll no longer have to wonder why you've spent all that money for camera and lenses, for the time has come to start figuring out how to get real action shots.

As a start, we'll cover the general techniques for use with all action events, and a bit later on you'll find a section devoted to putting together the techniques which seem most applicable to a particular event, game, or whatever.

You've presumably been practicing focusing, learning the direction the focus collar on your lens turns, and making sure there's little or no camera shake when you squeeze off your shot. In action photos, there'll be other reasons for blurred photos, but often in high-speed picture taking the subject will whip by so rapidly there's no chance for you to focus the camera. The cure for this problem is called pre-focusing, and it's a technique used by virtually every nonstudio professional photographer at one time or another. All that's required is some familiarity with the event taking place, so you'll have a good idea of where the action you want to shoot will occur. When you're setting up for your shot, just pick a spot about in the middle of where you expect the action to happen and focus the camera on that spot. Your depth of field, at anything more than the very widest lens openings, will cover at least several feet in front of and beyond that spot, allowing you to get sharp photographs of the action. I've always found it easiest to pick up an actual item and focus on that. At motor-

cycle races it can be a blade of grass or a stone, or a fault in the asphalt. At rodeos you can look for a clump of dirt to either side of the chute—certain rodeo events are very difficult to shoot well because the action can take place almost anywhere in the arena. Bulldogging and calf-roping are even more difficult than the various riding events where you've got chances at good shots just as the animals break from the chutes. At basketball games you can focus on the floor stripes, and if you're on the sidelines the rest is gravy. The action will generally move up and down the floor, allowing you to keep the same focus, assuming good lighting, for over 50 per cent of your shots. Once the pre-focus is made, just frame and shoot. It's easy when done that way.

A little practice at pre-focusing, using a loaded camera only after a half hour or so of unloaded practice, will help to build your confidence and sharpen your technique. Start with subjects that don't move too rapidly, and you should progress quickly.

Pre-focusing can be used no matter what direction the subject is moving, and no matter how fast it's moving, but subjects heading directly toward, or directly away from, you at very fast speeds require some thought and reasonably good reflexes. The reason for this is obvious. If the subject is moving across your field of vision, you've got a fairly long time to squeeze off a shot before it passes out of your "area of focus." If the subject's speed is very high, your shooting time will be cut considerably, but you'll still have a wide angle of approach and departure covered. If you're standing directly in front of—or behind—the subject, as it moves at high speed, the movement through your area of focus, which may be only 15 feet even on a bright day, will be extremely rapid. Lower shutter speeds can be used to open up the depth of field to some extent, but the reaction time allowed by across-the-bows movement, so to speak, is much greater than that given by head-on movement.

As an example, let's attend a motocross race at Unadilla Valley Sport Center some 30 miles south of Utica, New York. Standing off to the side of the starting line, we pre-focus about a third of the way out into the starting area, the area where most of the machines will be congregated as they all try to get into the sharp righthand turn first. The starting line is off to our left, and the curve another 75 yards to our right. As the starting gate drops, we

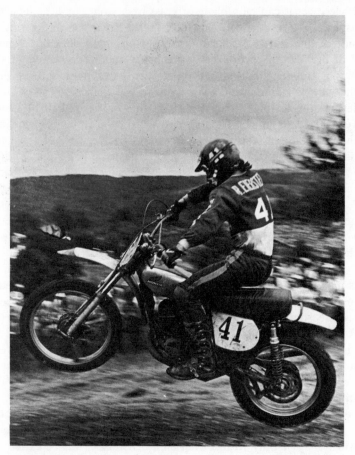

Figure 2. This photograph illustrates many things. Taken on a bright day at Unadilla Valley Sports Center, New Berlin, New York, it is pre-focused and sharp (giving you an idea of what you can expect when pre-focusing), shows good action of the up-hill Screw U jump, and has all the characteristics of a fine photo. But, during the home processing of the film, an insect slipped onto the film before drying was complete, leaving the nasty blip right over the front fender. The photo also shows that, with a bit of practice, a twin-lens-reflex camera can be used for action photography; in this case it was a Yashicamat. PHOTO BY THE AUTHOR.

grab a shot of the front wheels bumping over the top bar well before it drops all the way into its slot. Front wheels paw the air and rear wheels tear the dirt as full-power shifts are made and the riders vie for position. A slight pivot keeps the camera lined on the half-dozen or so leaders, allowing us to snap off another two or three shots without changing focus as the riders move directly across our front.

As the field thunders around the first turn, we spin and start running for the jump called Screw U. As we approach, the engines scream, protesting as the riders kick down two or three gears and grab handfuls of brake for the drop-off jump into the crevasse. A quick pre-focus on the edge of the uphill jump allows just time to spin and check that focus on a point the same distance behind us. Now the leader leaps from the lip of the ravine and we snap a quick shot of him as he flies 6 feet into the air at some 30 or 35 miles per hour. As we spin we feel the thud, the shock of rider and machine hitting the ground, and we manage to get one more shot of his rear tire tearing at the ground, the search for traction as he looks forward to the hairpin curve another hundred yards up the course. That's it. Two shots of any one rider or group of riders, if you're quick and if you're lucky. Often it's best to let the second shot go and try to catch action as the pack breaks over the lip, with as many as six riders clearing the ground at one time.

With this type of shot, the rider is headed directly toward you at between 30 and 40 miles per hour, and passes through your 10- or 15-foot area of focus very rapidly. Of course, a motor drive will give you more shots. But here the hand-advanced film allows a bare two shots, often only one, as the rider covers 40 yards or more about as quickly as you can spin and shoot. Still, you will have a shot. Pre-focus gave them to you, while those nonclued-in types were trying to focus on the flying motorcycles and got nothing but blurred and out-of-focus junk for their pains.

Pre-focusing goes hand-in-hand with a phenomenon known as depth of field, which gives you a "area" of focus in front of and beyond the exact point of focus. Depth of field varies from camera to camera, and from lens to lens. The shorter the focal length, the greater the depth of field available at any particular lens opening (f/stop). The longer the lens, the less depth of field you have to

work with. Also, depth of field tends to decrease as you get closer to your subject—a problem for some of us at times, since part of the order most editors hand a photographer is the stricture: "Fill the damned frame!" And they're right. A picture is more dramatic when it includes only those elements necessary to tell the story. Showing a motorcycle as a tiny object against the sky may seem like a great idea the first time you take a picture of a jump. The second time you'll either move in a lot closer or buy a telephoto.

There are depth-of-field scales, as well as depth-of-field preview buttons, on almost all SLR cameras. You'll be able to check out the above statements, as well as the fact that depth of field increases vastly as you close down the lens. In other words, you have less chance of messing up the focus at $f/16$ than you do at $f/4$. The depth-of-field scale on my camera indicates a sharpness range from about 8 or 9 feet to infinity at $f/16$ (50mm, $f/1.4$ lens). At $f/4$, that sharp area decreases to 30 feet to infinity, or 3 feet to some 40 inches or so. At $f/16$, the close-up range is 3 feet to about 44 inches, an increase of 100 per cent, but still a good demonstration of the lack of depth of field at close range. For most action photography, the ranges under 10 feet won't get much use. Getting that close to the action is difficult in most sports and dangerous in many others. My nerves no longer stand up well to a car or motorcycle screaming by at speeds in excess of 150 miles per hour. I really don't trust anyone that much, especially since there is always the possibility of mechanical failure. Last fall, Brad Lackey, one of the premier U.S. motocross racers, came off the upper end of the Screw U jump at Unadilla while I was lying on my back trying to get an extreme low-level shot. This was during practice, and Brad was trying different lines to see which was fastest. He missed dropping on my left leg by about four inches. Would you believe the shutter jammed! The shot

Figure 3 and 4. The value of filling the frame as much as possible can be seen in these two photos. Both were shot with a Canon F1 on High Speed Ektachrome (converted to black and white, showing roughly the same area, during the International Six Days Trial, but Figure 3 of the Number 211 bike is much better.

Figure 4

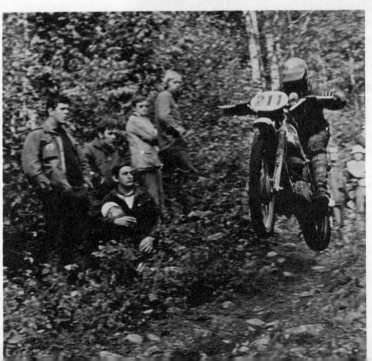

Figure 3

would have been fantastic, but the camera belonged to someone else and had a few unusual needs as far as loading and cocking are concerned—another good argument for knowing your equipment thoroughly! The shot would have been fantastic, as I said, but the next time I feel the need to take such action shots, a remote-controlled, motorized camera is going to take my place.

There are photographers hovering about who get their kicks from this sort of induced and unnecessary danger, but riders can get very unhappy about such actions. A bike-and-body collision can hurt the rider as well as the nut behind the camera. It has happened, and it will happen again, but not to me, nor to you if you follow my advice. Use a long lens for the real close-up photography, both for your own and the competitor's good. Psychic disruption is always a possibility where physical danger may not actually be present. A lot of sports require extreme concentration on the task at hand if the participant wants to win or do well. Don't interfere.

"Hyperfocal distance" is a technical term that can give you fits, but it can be a great help when shooting fast-moving action where pre-focusing for normal depth of field gives poor results. The formula for finding hyperfocal distance is complex and useless to us. The hyperfocal distance for any f/stop can be found by turning the lens focus to infinity and then checking your depth-of-field scale to find the nearest distance at which the lens is then in focus. You then simply re-focus the lens at this point and you've found, for all practical purposes, the hyperfocal distance.

With hyperfocal distance you'll get the maximum utility from any lens's depth of field or range of apparent sharpness, since everything from one half the hyperfocal distance all the way to infinity will be reasonably sharp, or in focus. Actually very simple and very quick in use, saving a great deal of diddling around with pre-focus in difficult light or subject conditions.

Hyperfocal distance, too, works just like any other depth-of-field problem. As the lens f/stops get bigger (smaller numerically), the sharp area of the hyperfocal distance decreases, and as you stop the lenses down their sharp coverage increases. A handy tool for those in a hurry or those who have difficulty with any type of fine focusing.

To repeat, set the focus at infinity. Check the depth-of-field scale on the lens barrel to determine the closest point now in focus. Set your focus at that point. The hyperfocal distance will now provide you with sharp pictures from half that distance to infinity. For example, a 50mm lens set at $f/8$ will have a hyperfocal distance of about 30 feet. Setting the focus there will give sharp results from about 15 feet to infinity. Under 15 feet will be out of focus. Certainly makes life easier, doesn't it?

We'll cover lenses in the section immediately following, so you'll know the advantages and disadvantages of short, moderate and long telephotos, and moderate wide angles, and how to get the most from each lens you own.

But on to action! Shutter speed becomes very important in action photography. Most of the snapshots taken around the house can be done at 1/60 second simply because everyone takes it easy for the camera. There's no way, absolutely no way, you can hold a camera still and be sure of getting good shots of, say, a running child at that speed. If you're at a track-and-field event with speed walkers, the guys who look as if their hip sockets were assembled in a ball-bearing factory, you'll need a shutter speed of about 1/125 second to stop the action. If you pull up by the 100-yard dash, set yourself up some 25 feet from the 50-yard mark and get ready to go, you'd better have a film/camera combination that allows for a shutter speed of 1/500 second! Those 25-mile-per-hour sprinters turn into blurs on film as well as in front of your eyes.

Normal cars, at city speeds, will require the same shutter speeds as do sprinters. Jack the speed up to 60 miles per hour and you're into the realm of high shutter speeds: 1/1000 second. For cars doing 100mph or more, the 1/2000 shutter available on a few of the more expensive cameras could be handy, but when speeds reach that extreme level, most photographers start to lean on one trick or another to capture the action.

The shutter speeds listed above are for objects or people passing in front of the camera, more or less parallel to the film plane. If you can cut that angle to 45 degrees, you can reduce the shutter speed by about one third. For action proceeding directly toward or away from you, you can reduce the shutter speed by a

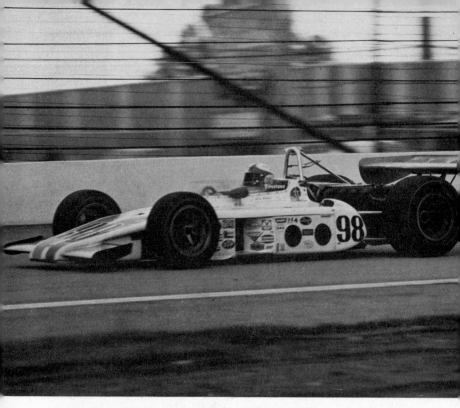

Figure 5. A good example of the use of panning, close-up action, of a single car is given dramatic impact by the blurred background.

full 50 per cent. So, even without specialized techniques, most action can be shot with cameras with top shutter speeds of 1/500 second. In actual practice, though, most action photographs are grabbed at much lower speeds, from 1/15 to 1/250 second.

The technique that makes this possible is known as panning, and requires nothing more than the movement of the camera lens with the subject as it speeds past the photographer. In fact, some really fine shots can be made at the slowest speed, 1/15 second, under many conditions. The variations that are possible with panning make it the single most important technique for the action photographer. Period. Panning and pre-focusing will give you all kinds of options you wouldn't otherwise find, and will prevent your having to use those extra-high shutter speeds on a car or anything else. No forced use of stop action will cause a

vehicle hitting 180 miles per hour or more to appear to be standing still. It *is* possible to get a photograph and lose a picture doing just that sort of thing!

The best way to begin your career in panning—after practicing for a fair length of time to make sure your movements are smooth, and that you're following through after you squeeze the shutter button—is to locate a spot where you want to take a picture and then observe the action. Watch several cars, motorcycles, horses, people, whatever go by your spot. Then place the camera to your eye and follow the next couple of prospective subjects around. Check for background. Check for color (if you're shooting color). Now pre-focus on the spot you've selected as your ideal. Pick up the subject you want to photograph as far from the touch-off point as practical: 100 yards or so won't hurt. As the subject nears the exposure point, start squeezing off your shot. Keep moving, following through carefully after the shutter is released. Follow-through motion in this type of photography is a seldom-mentioned but very important part of panning and is at least as important as follow-through in any other physical activity. The actual distance of the follow-through movement will vary with the speed of the subject. The faster the subject moves, the longer your follow-through should be, though you don't ever have to stay with the subject until it's out of sight. Just make sure you've gotten enough practice to release the shutter at the proper instant and to keep the camera on the subject as the shutter opens and closes, which can cover a good distance at 1/15 second. If you think the follow-through can be eliminated or shortened, you'll soon find yourself anticipating the release of the shutter and pulling the camera off the subject just as the curtain rises. Such tactics make for intriguing images, almost none of which are worth looking at.

Some photographers believe that shutter speed should be no more than 1/15 second when panning. I can't always agree with that. Certainly the slower the shutter speed, the greater the degree of blur around the moving subject. But a slighter degree of blur can be used to give a somewhat different effect, and, I feel, often a stronger overall effect. Any degree of blur will give about 1,000 per cent truer impression of speed, greater tension, to the resulting picture than will a very high shutter speed. Practice

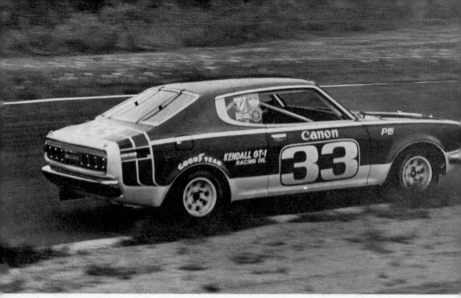

Figure 6

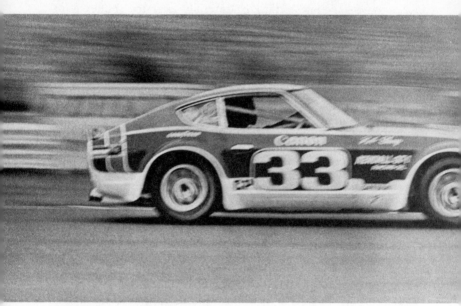

Figure 7

Figures 6 and 7. Panning can give good, sharp shots, with the subject properly positioned, or not so good, when events or technique problems interfere. The first photo makes a more attractive display than the second, where the driver unexpectedly stepped on the gas (hard!) just as the shutter clicked. MIKE MATZKIN/CANON PHOTOS.

shots taken with a variety of shutter speeds will give you a solid understanding of what can be done, as will some of the photos included in this book.

In general, more action seems to take place in a photo when there is some blur: a motorcycle with blurred spokes; cars with blurred wheels; runners who have slightly blurred heads, very blurred arms and legs and a sharply focused torso. Like any other aesthetic concept, this generalization is made to be broken. Consider the tense, sharply outlined muscles of a basketball player going to the boards, the strain and agony etched sharp and deep on his face. Certainly blurring a picture such as that would do nothing to improve the effect, and could easily ruin the overall effect. A rodeo rider suspended in air on the back of a twisting, leaping bronco makes a photograph which can in no way be improved by blurring. One of the best things about photography, or any other craft, is the huge degree of freedom available to the practitioner once the basics are stowed deeply in the mind.

Action photography presents the possibility of photographs which are nothing more nor less than color impressions of moving objects. Pan along with the subject, but allow the camera a slight up-and-down movement the instant of release (give it a bit of overlap, or you may miss the instant of release). You'll get sharply exposed color lines, along with a blurred background and foreground. Such photos always make me wonder whether or not the photographer wasn't just a bit clumsy, so impressionism isn't for me. No one can ever wonder if Picasso was clumsy, since intent is so obvious in his painting. But many of us who do not feel comfortable with the technique have junked pictures that, at least in retrospect, looked much like those we now see in print. If you like it, or think you will, go ahead. See whether or not you agree with me when the results are in.

Extremely long exposures can be made as the subject is panned. For long-exposure work of this sort, a tripod is almost essential to keep up-and-down camera movement from affecting the results. A tripod with a panning head (the head turns smoothly and easily either with a small handle or by twisting the camera body) is needed. You'll need to practice your panning technique with the tripod to get it all working smoothly before going out to take shots you'll want to keep. Pick the slowest color film you

can buy (Kodachrome 25). Load up, set the shutter speed at one second or more, and set the lens opening to correspond with your meter reading. Now pan along with the action.

If you're doing your slow-speed panning at night, the effects can be fantastic. A car being panned will be reasonably sharp, while lights all along the area panned will form streaks. You can, of course, reverse this procedure, keeping the camera still and letting the car's lights become streaks while trackside lights form haloed silhouettes. A lot of your nighttime results will depend on the type of film (use fast film at night), the quality of the overall light, and the possibility of a color shift in the film if the exposure is extremely long. Because color films are not designed to accept light over a long period of time, the color characteristics of the film change when such a situation occurs, causing what is known as a color shift—reds may go to magenta or purple, blues to greens, and so on.

Night photography is an entirely separate category and can be the source of some really fine photographs, with great depth and mood, all depending on how long you keep that shutter open. Experimentation is required, so make sure you've got plenty of film and the cash or credit to pay some pretty large processing bills.

Some starting points can be provided for you.

Spotlighted stage shows, such as circuses, can be shot with film having an exposure index (E.I.) of 400, at 1/125 second and $f/4$.

Basketball and hockey, with the same E.I. film, will require a 1/60 second speed at $f/2.8$.

Night football and baseball, at E.I. 400, will allow for 1/60 second and $f/4$. If the lighting is for television coverage, you can shoot just about as you would in daylight.

For panning shots at slow speeds, convert the shutter-speed/lens-opening figures as follows: If you see above 1/125 at $f/4$, move one stop down on shutter speed—to 1/60—and one up on lens opening—$f/5.6$. To go further, you'll get 1/30 at $f/8$. For really slow speed, 1/15 at $f/11$. For ultra-slow speed, try 1 second at $f/16$.

The above should give you a starting point, and your own experiments will provide all the rest of the data.

The catching of a basketball player at the peak of his leap for the hoop has already been mentioned, but will be covered here again, since such photography illustrates one of the harder-to-judge aspects of action photography. When slow shutter speeds are dictated by conditions—or by the desire to take such a shot— then the pendulum effect comes into play for the photographer. Certain types of action have a peak moment, a split second when the major action actually stops, as a pendulum does at the end of its arc, before it starts to swing the other way. Basketball players attempting to make or block a basket are only one example. Pole vaulters, high jumpers, bucking horses, a wide variety of subjects, all have this feature to some degree.

Essentially, peak-action, or pendulum-effect, photography is simply getting the shot as the subject reaches this "stopped" point. Here is where judgment is needed. You absolutely must be able to judge, within a foot or so, where that peak will be, or you won't get the shot. As in most types of action photography, a certain knowledge of the activity taking place is needed. If you don't know that most horses break into a wild first leap out of the chute at bucking events, how will you be ready to catch the animal suspended in midair?

Figure 8. This is a peak-action, or *pendulum-effect,* photograph taken at the International Six Days Trial in Dalton, Massachusetts. The rider has completed about 95 per cent of his slide, and the action has almost stopped as the bike prepares to scoot forward. Pentax 6×7 eye-level reflex, using High Speed Ektachrome (pushed to ASA 400 and converted to black and white), 1/60 at *f*/3.5.

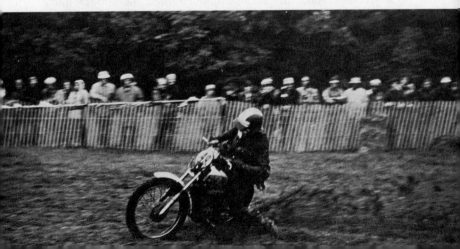

Probably you'll ruin a large percentage of the shots you take when you first start trying for peak-action pictures. At first, judgment of the proper point is difficult. Don't get discouraged, for after a time they'll start to fall in for you and the results will be worth it. You'll learn to judge the point where a car is going to have most of its motion in a particular direction scrubbed off as it comes through a curve. You'll begin to notice, often during the course of a single game, just where the best jump shots are around the basket. You'll start to anticipate the peaking of the jump for the pole vaulters and high jumpers at a track-and-field meet. Then you'll begin to get shots you want not only to keep but to display.

Pre-focus, again, comes in handy with the peak-action technique. Focus on the side of the basket during a basketball game, a clump of dirt at a rodeo, just above the bar at a field meet, and so on.

Differing admonitions from different people on how much should be in a photograph can drive a camera bug right onto a bar stool. My editors usually request that I fill the frame with the subject. While this often means one object, there can be as many as fifty motorcycles involved as subjects in a single shot. Usually, though, the subject consists of no more than three or four objects, and often only one. I try to include enough background and foreground to give a frame of reference. Nothing else. Blue skies may make dramatic photos as background for the local church steeple, but they don't do much for action photos unless you're shooting a skydiving meet.

Getting enough in the picture to tell the story can sometimes be a problem, since any inclusions other than the subject must be slipped in in such a way as not to detract from the center of interest: the subject. You can't tell a story when the subject is so small as to be detail-less and unidentifiable. If you're shooting a picture of an enduro rider hitting a deep mudhole in the woods, aim to get in just enough of the woods to provide a frame. The mudhole will include itself as soon as the rider slams into it, so let the bike rider and puddle tell the story.

Problems can really add up when you run into the type of clown who yells that you're getting in too close, that you can't get enough in the photograph that way. I've never been able to find

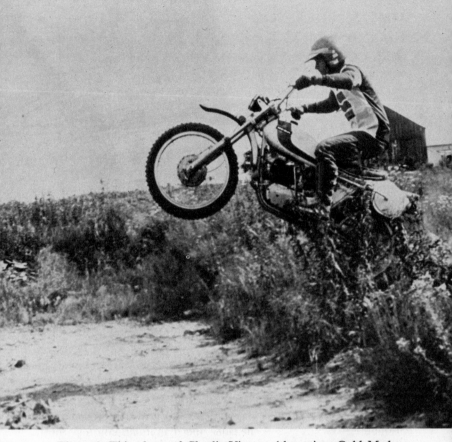

Figure 9. This photo of Charlie Vincent (three-time Gold Medalist in the I.S.D.T. competition) shows the attention that must be paid to backgrounds. This would be a pretty good shot without the barn; with it, it's nothing.

out just what "too" close is from any of these people. Why not get very close for at least a few shots? One of the most dramatic photos I ever took was a picture of the mud-coated face of motocross-racer Peter Lamppu, showing the tiredness and tension of a long, hard battle on the course. Was that *too* close, since it showed just his face? For some, the picture would be. It doesn't tell a total story. It shows physical and psychological tiredness. But it doesn't show how Peter got that way. Well, that photograph ran along with seven or eight others in a race report.

Basically, then, composition will be up to the individual. Given certain minor limits, you'll have to decide how far away to stand, how much to include in any one shot, what angle to use, and so on. Do attempt, sometimes, to tell all, or almost all, of a story in one shot. I think this sort of exercise can do a lot to strengthen your overall content. If a picture strikes your fancy, have a print made and display it. Your friends will admire it, if it's admirable, criticize it if it isn't, and ask for the rest of the story if that's necessary. Your enemies won't even see the thing, so why worry?

And that's about all we'll tell you about composition. There are many books, and sections of other books, on the subject. Some cover it well, others poorly, but it all comes down to the same thing. Do it your way until you find that your way doesn't work at all, then start looking for alternatives. You won't need a book for that!

All photography falls back onto one basic technique, now that you're well underway. Exposure. If you focus perfectly, frame beautifully, pan with pizzazz, and click away right on time, you won't have a picture worth a bean unless the exposure falls within proper limits. Learning to get a bit closer to the edges of the limits, when desired, is a big part of the secret of mood photography, and good photography. Let the sun pop through the front spokes as a rider wheels across a field, and the picture will have an entirely different feel than a shot taken in bright sunshine, with well-defined shadows and no light tricks. A silhouette can be a strong statement, though the exposure is all wrong for a normal photograph.

Exposure is, at once, the simplest and most complex of all the disciplines involved in photography of any kind. If you don't believe that, pick up the little sheet of paper that comes with every roll of film. Follow its modest instructions and you'll get reasonably well-exposed photos nearly every time. Now pick up a copy of any book—that tries to explain the use of Ansel Adams' Zone System of exposure—including the original (Adams' *Basic Photo Series,* (5 vols.). That's complexity in its finest form, but useful complexity inasmuch as a thorough understanding of Adams' Zone System will allow you to get not only clear photos *every* time, but will provide you with the knowledge to control

shades and such in the camera without having to resort to dark-room trickery.

Exposure, simply put, means you gotta get a reading of the light hitting or reflected from your subject, or you ain't about to get a picture looking anything like what you want. If you can figure out Adams' system, you're way ahead of the game. If not, try and tag along with me as I amble through the ways I try for consistent results.

Most of you, I'm sure, will be content to work with the exposure meters that came with your cameras. It doesn't make much sense to pay the price for a feature and then ignore it. Unfortunately, that's where my recommendations must start. For a variety of reasons, the meters installed behind camera lenses suffer from limits not forced upon hand-held meters. The biggest limiting factor is size. To all intents and purposes, the larger a meter, assuming near equal overall quality, the more accurate it will be. Accuracy aside, many in-camera meters fail badly when presented with unusual lighting situations (though a few newer developments help to counteract this). When a subject is lighted from the rear, you can run into problems. Trying to meter from the taking position will nearly always give you a photo that is nothing more than a silhouette. Moving in close to meter can help you to avoid this. Shooting into a bright sky or toward a bright sky can bring on some of the same problems: The main subject will end up severely underexposed, or the surrounding area will be totally overexposed. Unfortunately, in action photography it is usually impossible to ask your subject to move in close so you can meter properly. And it's just as often impossible to get your own body in close to get the readings. Few rodeo riders can hold the horse suspended in midair, and I doubt you really want to get in the arena with a Brahma bull.

Basically, there are two solutions. The first, and most expensive, is to purchase a one-degree spotmeter, at a cost of at least $150. Lovely, but the cost can be beaten easily by the second method. Look for the same light qualities closer to you. Then take a reading of a known factor. If you're shooting motorcycles, take a meter reading of a bike in your immediate vicinity. (The actual process would involve using an 18 per cent gray card, with almost no one

carries, but which everyone should. Try it.) If there is no alternate subject of a reasonable shade match around, you might try my favorite trick (assuming you've forgotten your gray card): Take a reading off the *palm* of your hand, held in the proper light. Most people have palms that register about 21 per cent on a gray scale, close enough to allow you plenty of latitude in shooting if you close the lens down one stop to make up for the increased brightness.

The oldest way, and usually the best, if at all possible, is to take at least two readings, one of the brightest part of the subject and the other of the deepest shadow. Then shoot about halfway between, give or take a stop or so, to emphasize what you want to emphasize. But, as we said, that sort of reading is often difficult or impossible in the field, or at fast-moving indoor events (where you'll more than likely be using flash anyway).

Eighteen per cent gray will remain in your mind, I hope. That is the standard of brightness that all meters measure, and it's a middle-range gray which shows up as having an 18 per cent reflectance value on a scale from white to black. Middle-gray subjects will meter perfectly each and every time.

Life, though, is a stinker. It slips us all these other light values, including hundreds, thousands even, that will never show up on a reflectance card. If you allow your meter to read without control, it will turn the largest area metered to middle gray and fill in other values to match that. Not the best way to get clean whites and solid blacks. So we're stuck with using some judgment to keep our photos from looking too washed out or shadowy. A bit of time spent checking the values of different subjects, with average flesh tones considered just a bit brighter than 18 per cent, will pay off.

It's easy enough to know that the white neckerchief on a cowboy will show up lighter than his deeply tanned skin, but what will happen to the rest of the colors in his outfit? Because your eye will be different than mine, and your camera will not meter quite the same way, and . . . well, there are many variables, forcing your decision to come from you. When you start getting it right, you'll know. Your photos will look as if the subjects are alive, the facial features will supplement the gradations of color

in the rest of the photograph, a perfectly white helmet or hat will seem right as compared to the sky in the background. In any case, you'll end up with the fullest possible tonal scale, with the clean whites and deep blacks associated with most good photos.

Later on, we'll take a slightly more complex look at meters and meter reading, but the above will get you going and keep you moving.

5.

Lenses

Most early cameras had only minimal lenses, or none. In fact, the lensless pinhole camera is still viable for certain techniques (they can be a lot of fun to make and fool with, but for action photography, arghhhh!). Today, a photographer can choose from just about anything anyone visualized in the early years—from the full 180-degree coverage of the true fisheye lens, to the 2.5-degree angle of acceptance (AA) (or angle of view) of a 1,000mm lens, and well beyond.

The angle of acceptance of a lens is of utmost importance, because only the part of your subject enclosed in the AA will be included on film. With the 180-degree fisheye—one of the most overused lenses of recent years—you have to take care not to get your feet into the photo. Generally, really short wide-angle lenses give a distorted view of the subject. That distortion can often be used creatively, but sometimes it ruins the perspective and overall feel of photos. Most extreme wide-angle lenses languish in the gadget bags after a few weeks of turning subjects and friends into freaks. The shortest lens in my bag at the moment is a 20mm, and I don't foresee a great deal of use for it, though it's as close to being distortion-free as I've ever seen in such a short lens. Part of the lack of use will come from my desire not to get clobbered—the majority of my work involves machinery moving at a rapid clip, so I prefer to stay back a bit. If your photography, however, involves field meets or other events where you can get in close with little or no danger, that 20mm will produce some very dramatic shots. For action photography, though, the wide-angle (WA) lens is an extra, something to have for special

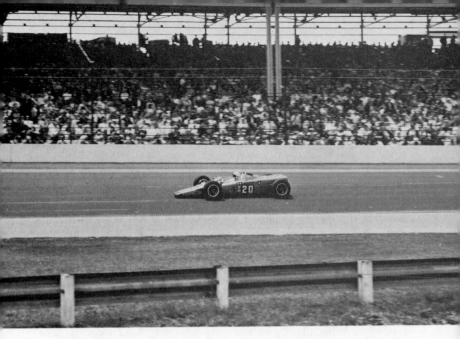

Figure 10. A slightly longer lens would have produced a more dramatic shot of Art Pollard driving the 1968 Indy turbine. FIRESTONE.

effects and unusual situations. WAs are at their best when you start to do the story-filler shots, the close-ups of tired and be-draggled faces, shooting to include and emphasize the lines and creases of faces almost crumpling from tiredness.

For the occasional panoramic shot, the WA is also needed. A 135mm telephoto won't enclose more than two or three slightly spread-apart skaters on a hockey rink, while the WA can get all, or most, of the rink, should you want or need such a shot. For the side or head-on shot of the start of a car or motorcycle race, the WA can present some drama, showing most or all of the competitors as they break for the first turn. Such shots cannot be taken with even a medium telephoto lens unless the photographer moves quite far back, probably out of position for any second shot.

Sometimes, though, the telephoto will allow you to grab the subject you're most interested in, central to one or two others, and then spin and catch a shot of the subject further down the course, even as far away as the first turn. It is this subject separation that makes the telephoto lens extremely valuable for the action photographer. You can get close without having to risk life and limb.

You can shoot faraway subjects without having to spend the entire day at a dead run to move in close. (All that running is not only hard on the anatomy, but can also mess up your photos as you try to focus, aim, shoot and catch your breath, transferring the resulting shakiness to the film. The laziest way is the best way, since it prevents camera shake.)

Much depends on course layout, and just as much depends on your own pictorial desires. What's just right for me, or one of my editors, might not do a thing for you. Which brings us right back to the basics of lens use, no matter what the lens. Think about it! Try to visualize the effect you wish and use the lens most likely to produce the result you want. If such visualizing doesn't work, mount the lens on the camera and practice viewing through it. Get your image sizes stuck in your mind in advance. What size does Larry Csonka appear to be in your viewfinder when he's at the 50-yard line and you've got a 200mm tele mounted? What about the size with a 28mm WA? How large is he when he's reached the opposition's ten-yard line? Move around with each lens, view the field of action as thoroughly as possible in advance of the event, and you'll have a lot better chance of coming up with the right lens at the right time.

Most action photographers swear by one or two telephoto lenses. The 135mm tele is considered by many to be the best sports lens for basketball, football, etc. Many race photographers consider the 200mm tele to be the backbone of their action work. Beyond a 200mm glass eye, you're getting into lenses which require a very steady hand and a great deal of practice to hold still during shooting. The ultimate in hand-held lenses is probably a lightweight 300mm, but for the average photographer there's little or no need to go beyond the 200mm. Couple a 200mm tele with a 1/250 or 1/500 second shutter speed, throw in a bit of practice, and you should have little trouble getting sharp photos. Since most normal lenses fall in the 50mm range, you're magnifying the image about four times with a 200mm telephoto. The 300mm will give you a six-time magnification, but will also magnify any camera shake by that much more.

Again, the lens is going to be dictated by the type and style of the action. For motorcycle road races, probably 90 per cent of the action can be shot very well with a 200mm lens and a normal

Figure 11. This is a fine example of the type of football action you can get with a telephoto lens. PHOTO COURTESY OF N.Y. JETS.

or wide-angle lens for close-up work. For motocross races, I personally prefer to get in a bit closer and use a 100mm or 135mm tele for just about everything. In fact, the shortness of most 100s allows you to use the same lens for shots in and around the pits when you're trying to add some human interest to your story later on. Longer lenses prevent your getting down low for a good angle at those action shots showing a racer high in the air coming off a jump or in a near-crash attitude—motocross is frequently described as controlled crashing—after slamming off the berm in a corner in preparation for a jump.

Your choice of lenses will depend primarily on the final results you want—unless you decide to try to sell the photos, and then you'd better be prepared to please an editor!

Lens speeds are another choice factor that seem to confuse many first-time buyers. Lens speed is nothing more than the time it takes for a lens to transmit light onto film, expressed mathematically as f/stops. Lenses today can be found with wide-open "speeds" ranging from f/1.2 on up to f/8. The smaller the f/stop number, the more light your lens can gather when wide open. On a rating scale, f/2 is twice as fast as f/2.8, which is twice as fast as f/4. Full stops on today's lenses usually run to about f/22, an opening which provides fantastic depth of field on all but the longest telephoto lenses.

Too many first-time buyers go for the fastest lens available, paying little attention to their real needs. Such choices can run expenses out of sight, since fast lenses cost more to design and manufacture than do the slower models. If most of your shots are taken indoors, using no flash, look for and buy the fastest lens you can afford, whatever the focal length. If you plan to make extensive use of flash, or do most of your shooting outdoors in bright daylight, look for the slower lenses, get as good or better picture quality and take advantage of the opportunity to save a fair sum on each lens you buy. A few examples are in order here. The Canon FD 35mm lens, with f/3.5 speed is just about half the price of the FD 35mm f/2.0 lens, for a savings of over $130; the FD 135mm f/3.5 is about $75 cheaper than the FD 135mm f/2.8. Is half an f/stop worth $75 to you?

Most action photography can be handled very easily with the slower lenses, using fill-in flash when needed. Remember, too, that today's films offer the highest speeds in history and aren't at all likely to go down (Kodak's Tri-X is rated at ASA 400, but acceptable push-processing will give good results at ASA 600 to 800, which is one-half to one f/stop faster). Less acceptable grain and shadow detail can be had by using Kodak's Royal X Pan, ASA 1250. Even color films have won the speed race, with Kodak's High Speed Ektachrome rated at ASA 160 and available in Kodak push-processing at E.I. 400. GAF's 500 offers a rating of ASA 500 right from the start, though it has a tendency to be grainy and overemphasize reds (don't push-process GAF 500, as it tends to go toward magenta when an E.I. of 1000 is used).

Some of the shortcomings of each of the two types of lenses should be listed so that you'll have a reasonable idea of what

you're getting into when you flip open your checkbook on the dealer's counter.

Wide-angle lenses offer the greatest depth of field of all lenses, and the shorter the wide angle, the less will be your need for fussy focusing in action situations. Your zone of sharpness will extend a very long way, keeping the foreground, the subject and the background in sharp focus. This is extremely handy when the going gets hectic, but it also makes background and foreground control difficult or impossible, so a plus feature is also a minus feature at some times.

Edge distortion is almost always present with a wide-angle lens. Used creatively, such distortion can give you some very pleasing effects. Used without creative ideas, or with trite ideas, edge distortion can really louse up photographs. Again, the shorter the lens, the more extreme will be the effect. Few 35mm and 28mm wide-angle lenses suffer strongly from edge distortion, but below 20mm things can get bad. If you want a short lens with little or no distortion problems, you're going to have to pay a wicked price.

Telephoto lenses too will give problems when shooting certain kinds of events. While they are ideal for isolating the subject in a photograph, in other pictures telephotos of extreme length can bunch things up pretty badly. This is called depth distortion. Depth distortion means that cars actually a long way apart will appear to be grouped rather tightly in the final photo. This feature can, like wide-angle barrel distortion, be used creatively with great effect, or it can destroy the overall effect of almost any picture if the photographer is not constantly on guard against it. Of course, we've already mentioned one other problem area with telephotos: the magnification of camera shake. Generally, tripods are used to control this problem, but if you really want a day's exercise in futility, try lugging a camera with a 300mm telephoto on top of a ten-pound tripod. All your shots will be of the same area after the first hour or so of toting that mess around. A better cure for the action photographer is the monopod. This gadget has a single leg, weighs only a pound or so, and can really do a job of fighting shake and blur. If a monopod is not available, try resting the camera against a handy object such as a car top, a stone wall, a tree, a fireplug, whatever. At worst, brace your

hands more solidly (and get in some more steadiness practice at home).

Generally, the longer teles (200mm and up) present the most extreme examples of the above problems. Those longer teles, and most zooms, will usually have a tripod socket on the lens itself, which I tend to prefer to the one on the camera base. It's no more sturdy—tripod sockets are never right, either too shallow or too deep for the screw on your tripod, so that there are always problems—but I find that the monopod on the barrel gives me a better balance with the long lens than does the monopod stuck in the bottom of the camera. Especially with a motor drive attached. Still, this is a personal matter. Try it both ways and select the one that feels best to you.

Telephotos offer two other problem areas. The longer the lens, as you've probably gathered from the fact that shorter lenses go the other way, the more critical the focusing. Depth of field drops off sharply as the length of a lens increases. This is part of the reason I seldom use lenses over 200mm for action photos. You have to be superquick and superfinicky to get decent focus if the subject slips only a foot or two off your pre-focus spot. More guesswork, extra film, and additional practice are necessary for long, long lenses.

As telephotos lengthen, you're snapping away through more and more air. Your subject is further away from the end of your lens, and you can easily run into problems of air quality. Air at most sporting events is not perfectly clear. Cars and motorcycles create haze. Cigars, cigarettes and such create haze at indoor events. Smog or smoke exists in profusion around major cities. Haze filters are available. Try medium yellow for black and white film, or an ultraviolet (UV) filter for color film. Probably not essential on 135mm and shorter lenses, unless conditions are exceptionally bad, haze filters become nearly essential on lenses from 200mm and up.

Now we come to that fancy lens: the zoom. The zoom is not beloved by everyone. Many pros feel they must have the ultimate in sharpness on each and every shot, and refuse to use zooms. To date, and probably for some time to come, zoom lenses do not produce quite the overall sharpness of a top-quality single-focal-length lens, though they are much better than they were

five years ago, and are about 100 per cent better than many pros believe. Equipment snobbism is rampant in photography. Zooms will give you sharp, clear photos if used properly, assuming you've bought one of the better models.

Normal precautions to prevent camera shake are even more necessary with these nose-heavy lenses, and greater attention to accuracy of focus is also a help.

Zoom lenses will not replace an array of lenses in single focal lengths for everyone, but for others a good zoom in the 80-to-200 or -220mm range will do just about anything they'll ever want, plus some.

Zooms offer a chance at getting several shots from a single vantage point, giving different subject sizes without your having to run back and forth. You can zoom back to pick up the entire line ready to start a race, then zoom in and capture a shot of a fractious horse rearing as it enters the starting gate. You can catch two or three horses breaking into the lead as the gate opens, then shift and catch only the leader, or go the other way and get the entire field. All of this without moving anything other than your hands. Single-focal-length lenses would require several lens changes, with the assorted hassles of finding the right lens, getting the wrong one off and attaching the new one, usually finding the action has passed you by when everything is finally ready. Good zooms will even come pretty close to holding their focus as you shift focal lengths. Not perfectly, of course, but only minor corrections should be needed.

All of this sounds, now that I look back, as if I'm recommending zoom lenses. I guess that's true. With a zoom you're more likely to get more and better composed photographs, at a lot lower overall lens cost than with a whole series of single-focal-length lenses. With the zoom you can compose and crop right in the camera, almost to the final degree possible. (The fact that most SLR cameras show you only about 95 per cent of the overall scene being photographed keeps you just a touch away from perfect composition, even when you've gotten used to including the missing percentage.) You can move in or move back, include a little or a lot—without extra effort, and with little more than the energy required to open a cigarette lighter. Because of this simplicity of use, there's a lot of gimmickry involved in zoom

photography, a lot of pictures which should never have been taken get taken, simply because it's so easy. But a lot of good shots that would have been missed during a lens change are also taken. My feeling is that it all balances out. If you're not looking for the ultimate—say, a third of a 35mm transparency blown up to 16 by 20 inches—the sharpness and clarity of a high-quality zoom will please you.

Zooms will give results that can't easily be duplicated with other equipment. Swirls and the now standard zoom shot with color or light lines extending in—or out—to the main subject. Though much more difficult to bring off in high-speed action photography, these tricks can still work and will sometimes produce effective photographs. Most of the time you'll toss the result in the trash before anyone else gets a look at your mistake. The few that do work may more than make up for the dozens of discards.

The difficulty of zooming in on a moving subject—during exposure—becomes apparent when you realize that relatively high shutter speeds are needed to capture an object in motion, and relatively slow shutter speeds are needed to allow you to zoom in to form color streaks. Still, by proper positioning, some advance planning and with the proper amount of luck, you can get shots of foot racers, slower types of motorized competition, rodeo clowns, sailboats and so on. If you've got plenty of film-processing cash, you can even make your tries with higher-speed events such as Grand National Stock Car racing and motorcycle road racing. The technique is simple: Select a shutter speed of 1/15 second or less, line up your subject and focus. Or pre-focus on the spot you expect your subject to occupy. Then as the subject comes into your finder, squeeze off the shot while you pan along with the subject *and* zoom the lens, zooming in or out as you choose. The longer the shutter speed, the more effective this technique is, so a tripod becomes necessary to prevent camera shake while panning. The tripod must have a panning head (most good tripods come with one) so that you can swing the camera through its arc. This technique, used with very long exposure times at night, can have fascinating results.

There are other zoom techniques, as you will discover, but the above is about the only one really applicable to action photog-

raphy, and should produce a reasonably high number of usable shots after you've gotten in a few practice rolls. You'll come up with your own variations on the theme as time passes and you'll make "mistakes." Keep track of the mistakes, for they'll often produce some of your best photos, as well as your worst. If you can repeat the beneficial mistakes and eliminate the malignant, you'll be way ahead.

Those are the three basic types of lenses: wide-angle, telephoto, zoom. There is, of course, the normal lens that usually comes with a camera. (You do *not* have to buy any lens at all when you buy an SLR camera, but most SLR cameras are sold with normal lenses ranging from about 50 to 58mm in focal length.) You can get a great deal of use out of a normal lens in action photography, but it requires more thought and planning, and a bit more work. By the way, this lens is called "normal" simply because its approximate 43- to 45-degree angle of acceptance comes close to that of the average human eye. My recommendation for a lens collection start would be to accept the normal lens the salesman so dearly wants you to have. Get the slowest speed available, however, as there can be well over a $150 difference in cost between an $f/2$ lens and an $f/1.2$ lens. Do all of your photography with that lens for a few weeks, until you are thoroughly familiar with the camera. The pictures you take toward the end of that time should begin to indicate what the normal lens is not doing for you. Are you always too far away from the main subject? Are you always in too close, cutting off necessary parts of the photo? If the former is your problem, a telephoto or a zoom lens should be on your list. If the latter problem is yours, then shop for a wide-angle lens.

The selection process goes on. Look next at the lens speed. As we mentioned earlier, the fastest lens in the world is no bargain, since it costs much more to make. If you're never, or seldom, going to use that speed, don't pay for it. Use a higher-speed film or flash to help out in the low-light situations you can't avoid.

If you're shopping for a camera and a lens at the same time, look for a bayonet-style mount. Buy your camera with this feature in mind at the outset. Bayonet bases on lenses allow you to swap lenses more quickly, assuming you don't spring for a zoom lens. (But also remember that the Pentax cameras, with their screw-in

mounts, have about the widest possible selection of reasonably priced lenses available for any camera—and Pentax-style mounts are used on many cameras other than Pentaxes.)

There are two primary reasons for preferring bayonet mounts to screw mounts, though in general use only one really makes much difference. Screw-mount lenses take longer to change. Period. They are also said to wear a bit more rapidly, falling out of alignment with the camera body more quickly than a good bayonet or bayonet-and-lock mount, but I've heard few complaints about either style as far as wear goes. For the average camera user, such a problem should never exist. Bayonet mounts simply are a fraction of a second quicker when you're making a rapid lens change while covering an event. If price, availability or other factors make the screw mount more desirable to you, go ahead and buy that type.

Look for quality in a lens, but don't go way overboard. If you'll be using the lens only a few times a year, you just don't need the strength built into most lenses intended for use by professional photographers. You'd just be wasting cash to buy the ultimate, the absolute and unequivocally best lens on the market —assuming there is any such thing—when, for many pesos less, you can get almost the same picture quality at a minor sacrifice in sturdiness. Don't forget, too, that accessory-lens manufacturers make a wide variety of lens qualities. While a few of them compare in quality with original-equipment lenses, most are a cut or two inferior to lenses from the camera manufacturers, usually because of a somewhat less than perfect fit of the lens mount to the camera. This comes about because the accessory-lens maker has to produce a lens that can be easily adapted to a wide variety of cameras, while the camera manufacturer cares not a bit that his lenses won't fit a competitor's camera. With the higher-priced independent lens makers, the glass and overall construction may be just as good as the lens produced by the camera manufacturer, but the price will probably still be significantly lower, because much larger numbers of the basic barrel will be sold, thereby lowering the unit price.

Before buying any lens, try it on your camera for fit. If there's an easily perceptible slip in the fit, take it off and hand it back to

the dealer. A loose fit on a new lens will work out to be total uselessness in an older lens—and not very much older at that.

Make sure the lens you buy couples with the camera you own in every mode. Until a short time ago, buying accessory lenses for the Canon F1 and Nikon F2 was something of an adventure, since most of the mounts available forced you to stop the lens down to use the camera's meter. Now, for an extra ten or twenty bucks, the mounts allow full aperture metering, a real timesaver. This is a strong consideration for those of you who have or will buy automatic cameras. Make sure the lens works in automatic modes as well as in manual.

If you have a normal lens which turns to the right to reach infinity on your focus scale, make sure *all* of your other lenses also turn to the right to reach infinity. This has nothing to do with lens quality, but it has a great deal to do with ease and simplicity of operation in stress circumstances. If you have to remember a different direction of focus for each and every lens you pull out of your bag and attach to your camera, you've got that much less attention to direct to proper focusing, composition and metering. Avoid complexity wherever possible.

Avoiding complexity is a fine idea when buying lenses anyway. Don't get too many. Don't get the wrong kinds. Don't waste time and money on equipment you'll seldom, if ever, use. A little checking and forethought will increase the chances of your acquiring only those lenses you will need for the pictures you want to take (let the excess glass eyes remain on the dealers' shelves). Any sport, hobby, recreation, or whatever is more fun when it doesn't bankrupt the participant, which is what you avoid by making thoughtful selection of all your photographic gear.

6.

Filters

For years, the only filter my camera bag contained was a skylight 1A. In my opinion, Kodak's fast color film, High Speed Ektachrome, went a bit too far toward the blue side of the spectrum. The skylight filter reduces the blue overlay too often noticeable in older transparencies shot on High Speed Ektachrome. A skylight filter has little or no effect on the amount of light reaching the film, thus leaving your shutter speed and lens-opening settings alone, but it gives a much better rendition of colors on days when there seems to be too much blue light around. It also has a tendency to warm the overall tone of the photos.

In general, filters are good for adding or subtracting from scenes. They also do a fine job—the skylight filter is particularly good for this—of protecting the front element of your lens. Still, filters are another subject where too much complexity can mess up your fun. There are literally dozens of filters available, of which you'll need no more than six in a normal year of picture taking. The odds are pretty good that you'll have little or no trouble getting along with one or more. If you're going for the zero figure for the time being, at least read on and see how your pictures can be improved. If you're going with one, trot on out and buy a good skylight 1A of the proper size.

Outdoor events sooner or later do us all in when the sky becomes such a light blue that objects such as a white crash helmet (on black and white film) tend to fade into it. Your headless horseman might look fine on the cover of a book by Washington

Figure 12

Figure 13

Figures 12 through 21. This series of photographs illustrates the difference that filters can make in black-and-white photography. In Figure 12, a Number 15 yellow filter greatly improves the sky as compared with Figure 13, where no filter was used.

Figure 14 was taken without a filter. The use of a Number 8 or K2 (Figure 15) filter, again yellow, improves the gray tones.

The red of the apple and the green of the foliage are too close in rendition in Figure 16, but by using a Number 58 (B) green filter, the red of the apple is soaked up, allowing the green of the leaves to pass, with the result (Figure 17). By using a Number 25 (A) red filter (Figure 18), the red from the apple is transmitted, while the green from the leaves is absorbed. This filter will always lighten red subjects and darken greens (on black-and-white prints).

Even without a filter, the scene in Figure 19 provides a dramatic shot, but adding a polarizing screen or filter makes the resulting sky even more dramatic (Figure 20). For the most dramatic results, use a polarizing screen in conjunction with a 25 (A) red filter (Figure 21).

FILTER PHOTO SERIES REPRINTED WITH PERMISSION FROM THE COPYRIGHTED KODAK PUBLICATION, *Filters for Black and White and Color Pictures.*

Figure 14

Figure 15

Figure 16

Figure 17

Figure 18

Figure 19

Figure 20

Figure 21

Irving, but won't do much to enliven a magazine spread or the walls of your home. To darken that sky just a bit, a medium-yellow filter (or a light-yellow filter for less darkening effect) will do a fine job. The yellow filters also pick off some of the yellow light going to yellow and red subjects, causing them to come up a bit lighter than is usually the case. Clouds will also be emphasized as the surrounding sky gets darker. If your headless horseman has his cranium against a cloud, you won't be helped, but otherwise the yellow filter will do the job.

A red filter is another black-and-white-film effect producer (reducer). It's also necessary for infrared film. For moonlight effects shot during daylight, this is a wild one. It lightens reds and greens while darkening blue subjects, so it can replace the yellow filter to darken skies, if you wish (it also will not lighten yellow, which may help the total effect in some cases). Deeper blues, no washed-out yellows, but lighter reds and greens. I still haven't figured out a justification for using infrared film in anything other than technical applications, so will have to leave to you the sorting out of infrared and red filters. The results on black and white always look slightly odd, but not odd enough to be really interesting.

Orange filters are sky darkeners too. Yellows and reds will pull up lighter, as with the yellow filter, and the clouds will pop right out at you. Bluish haze is also penetrated to a fair degree, as this filter absorbs blue and a bit of green light.

Green filters lighten foliage, giving, according to Kodak's Master Photoguide (a very handy little book, by the way), improved rendering of texture in sunlight. Natural skin tones—those greenish hangover shades are removed—are retained and the sky darkened (again!) with green filtering.

An ultraviolet filter, again for black-and-white film, picks up that excessive ultraviolet light that bounces around on snow, sand and water and filters it out, giving you better telephoto shots. It also does a job of slicing through haze.

Neutral-density (ND) filters are for special uses and do absolutely nothing to change the color of transmitted light. All they do is reduce the amount of light coming through the lens. While this may sound the reverse of all that photo technology tries to do

these days, what with high-speed films, cameras and lenses, the ND filter can be a great help when you find your camera loaded with Kodak Tri-X, a bright sun bouncing off the beach, and a boat race or some other activity you want on film taking place. Occasionally you won't get a thing, because your camera won't drop under $f/22$ at 1/2000 second. Or you'll be forced to shoot everything at $f/16$ and 1/1000. No options. No chance to add blur or some other technique to get more feeling into the picture. The ND filter (2X, 4X or 8X) will give you the options by effectively cutting your film speed (2X is about one f/stop, while 4X is two, 8X three, and so on—and, no, I don't know why they couldn't have used 1, 2, and 3!). These filters can be used with either black-and-white or color films.

Polarizing filters are sort of odd little things, usually with a small handle kicked out from the side. You twist or wiggle that handle until you see the effect you want, and then: click! The effect of a polarizing filter should be familiar to most everyone these days. Basically, it's a glare reducer, which also tends to make colors deeper and more dramatic. Useful in both black-and-white and color photography, this would be the second filter in my bag if I were limited to two. Blue skies are darkened, windows don't send glaring beams of light, and all kinds of good things can happen. Put one on your camera and give it a check.

If you slip up and find yourself with half a roll of daylight film in the camera and need to shoot indoors without flash—say, under incandescent lighting—an 80B filter will help to clear things up, preventing the usual rather nasty color cast that results from using daylight film under artificial lights. The reverse can also be true. You find yourself outdoors under a bright sun with a lot of film left on a roll of Type A color film. In this case, slip on a Number 85 conversion filter and look for reasonably good results. In fluorescent light, you've got a problem, no matter what kind of film you use. Recommendations vary for brands of film, but Kodak calls for a variety of filters, depending on the kind of fluorescent bulb in use. Enough to drive you nuts. You really have only two choices here: Use GAF 500 film, which for some reason has pretty fair—not good, but fair—unfiltered color under fluorescent

lights; or use a blue-flash fill to override most of the sickening green light cast by fluorescents.

This doesn't cover all filters, nor does it come close to covering all their uses. There are many variations of each color, there are gels, there are diffraction gratings, there are prisms, there are blue filters to create haze, and so on. The above will carry you through the normal filters, the ones you'll be most likely to find a use for in your photography.

For strange and outlandish effects, you can try using black-and-white filters with color film. A red filter will cause highlights to come up red, a green filter will bring them up green, and so on. Odd results, often. Garbage, just as often, but the experimenting can be fun.

When you start shopping for filters, be careful.

Filter purchasing is one area where trying to save money is not a good idea. A filter must be as good as the lens to which it is attached, or it will degrade the final image. Filters must be perfectly flat and set into screw-in or drop-in mounts that will fit the front of your lens without binding. A pocketful of rainbows if you get the right kinds and quality, but a mess if you buy cheap stuff that ruins all the work you've done to get a good picture.

Filters should also be protected when not in use—after all, they're made of ground optical glass, just as your lens is, and they cost quite a bit for their size (probably $3 to $6 apiece, with polarizers and other specialty filters reaching well over $25). Pick up a filter safe to make sure that dust and scratches are not acquired during storage.

Camera Accessories:
How to Go Broke
in One Easy Lesson

Almost by definition, the camera nut is also a gadget nut. Why that should be so I'm not positive, but it seems to have something to do with the precision needed to take good pictures, plus the love of good equipment that tends to sooner or later become the lot of every owner of a fine camera. As an example, I've hardly handled a gun of any kind since my discharge from the military, and don't have a firearm of any kind in the house. But the fine woodwork and precision machining of most rifles and pistols put the hand of temptation on me fairly often, though I've got absolutely no need for a weapon of any kind, since I'm retired from target shooting and don't care for hunting. Exotic motorcycle engines and frames turn me on. Ecstasy on any day can be a long stare at the innards of a Ferrari engine. The next day I'll have the lens and back off one of my cameras, "checking" the works. I do my own auto tune-ups and repairs. Not that all this is essential to good photography, but my reactions are close to typical, so gadgetry can easily slip in and getcha—right in the wallet.

Probably the single most important accessory you'll ever buy is a tripod. A tripod will offer much more than you believe possible to the action photographer. Long lens photos will become unbelievably sharp, and a good, smooth panning head will improve your pan shots hugely. A tripod will allow you to plant and aim a camera with a remote-control switch or long release. This allows you to stick the unit into areas which could prove hazardous to life, limb and insurance premiums, with only the mechanical stuff

at risk. Getting your gear smashed to pieces is an extreme way to take photos, but it beats getting your body *and* your gear smashed.

Tripods, like almost every other piece of photo gear, come in prices ranging from very cheap on up to ridiculously expensive. Look for sturdy legs which will lengthen enough to give you the maximum height you want, but which will also telescope enough to be easy to carry—and to allow you to take low-level shots while using the tripod. Get a unit with a pan head, and check the pan head for strength and smoothness of operation. Do this by mounting your heaviest camera/lens combination and testing the panning motion several times, both fast and slow. Be careful not to overdo things here. Some tripods are too heavy for practical use (those big enough for 16mm and larger movie cameras) while others are too light to give solid support. Get a middling, heavy or middling-light tripod, as your tastes and wallet dictate. For action photography you want to be able to carry the thing without herniating yourself, while still getting a solid base for your camera.

If the tripod has spiked ends on the legs, make sure that rubber caps are easily attachable when the tripod is used indoors or on a hard surface. Make sure the friction collars—the most usual method of tightening the legs in any one position—will hold with your camera/lens unit in place. If it won't hold well when new, don't expect improvement as time passes and wear and tear accumulates.

Check the tripod screw as it enters the base of your camera to make certain it's not too short to hold. If it is, find another tripod. If the screw is too long—which is more apt to be the case —locate a few washers to make things come out right. Screwing it in too far can really mess up the threads on your camera's tripod socket, and can sometimes warp the camera base plate, so be careful here.

The tripod will take care of the major-league bracing, but for those runaround days when there will be little chance to open and close tripod legs and get everything level, look for a monopod. Much cheaper and lighter than a tripod—let's face it, it's only about a third as good—the monopod will nevertheless provide a great deal of help with long lenses in many situations. No pan head, just turn the pole. Make sure the thing telescopes far enough—I like the ones which close down to 18 inches or less,

because they can be left on the camera most of the time. The same advice holds true for friction leg locks and the monopod screw as for the tripod.

At the same time you're selecting your tripod and/or monopod, you should be looking for one other thing: a camera strap. Two things come with too many cameras. Both are almost totally useless. One is the flimsy strap. The other is the never-ready case. If you find yourself the abashed owner of these things, you can either drop them in the back of the closet or into the nearest trash barrel. Almost all SLR cameras, by the way, are available without the case for a few bucks less. Insist on it being left off. Now'go to your local camera store. Select a good, over-one-inch-wide camera strap with good solid snap swivels mounted on both ends. If you want, get a fancy one with embroidered designs and whatnot. But get one and make sure it's a good one. Don't get one of the chain style unless you enjoy feeling as if a saw were at work on the back of your neck. And stay away from those harness contraptions which hold the camera in at least three spots and force you to disconnect what seems like two oxen from their yokes before being able to lift the camera to your eye— those that don't put you through the unhitching always seem to work loose when they should be staying tight. Since these body-surrounding monsters are only made to keep the camera(s) from slapping around and banging into each other while you run or trot, the second style is nearly useless. If you run with a camera around your neck, use a hand to hold it. The harness is a pain, adding complexity and cost. Using a hand is cheap and it works! If you've got more than one camera, things do get difficult, but try slinging one over your shoulder instead of over and around your neck. It may then bang against your side, but it will keep the expensive stuff from smashing together as you scoot along.

After you've bought the above, in addition to your camera and lenses, you will have the essentials. Anything past this point is gravy, not adding to the essential picture-taking task in anyway except convenience. Some will greatly increase convenience. Some will slightly increase convenience. All of it is fun to collect. Some is quite costly in one shot, while the smaller stuff just builds and builds until you find you've got no money left to buy film. It's all optional.

Lens shades could almost be added to the necessary side of the accessory list, but generally a reasonably good lens shade comes with each lens. From that point on, you're truly on your own, since there is a great, almost crazy, variety of shades floating around, varying in shape, size and material. Sooner or later, you'll lose your original shade and have to spring for a new one. Wait until that happens. Then go for one of the foldable rubber ones such as those sold by Spiratone (and others). These are light, sturdy, and can be rapidly turned back out of your way should they become a bother (they won't).

Changing bags are another item seldom needed, but hard to replace when film jams in your camera and you're sure there are a half-dozen great shots on the roll facing ruin when you pop open the back to clear things out. A two-layer bag of lightproof cloth, with elasticized sleeve openings for hand entry and two zippers, changing bags come in many sizes. If you want to change the film in a 400-foot 16mm movie-camera magazine, contact Omar the tentmaker. If you only want to clear jammed sprockets in a 35mm camera, select a size just large enough to accept the camera and both your hands, leaving a little working space to get the back open after insertion. The six or seven dollars that such a bag costs is a worthwhile investment for anyone using a camera a bit more than average and caring a bit more than average for their photos. Stuff the bag in the bottom of your gadget bag—it makes pretty good extra padding—until need for it arises.

Try to make sure the changing bag isn't always folded on the same creases. Extra wear on such points can eventually cause light leaks, making the bag worthless no matter how good it was new. Substitute: a heavy jacket, suit coat or overcoat can be folded and used as a changing bag if you can find some deep shade or very subdued light to work in. The changing bag is much preferable, particularly in warm weather when you're unlikely to have extra outer clothes with you. If you use a jacket, be careful to eliminate any light leaks when folding, and use the sleeves as points of entry for your hands.

Gadget bags are next on the list of accessories. There are probably more such bags available than any other single item except cameras and lenses. Gadget bags come in about every luggage form known to man: soft, hard, square, rectangular, shapeless,

metallic, fabric, vinyl, leather, large, medium, small, lined, unlined, compartmented, and a multitude of other choices, including expensive and cheap. For the greatest protection of any type, the Halliburton style of aluminum case, with foam liners cut to hold specific items of equipment, are probably the best. But they're almost useless in the field, and they present the bystander, who may not be your honest Uncle Abe, with a pointer saying, "Here's a lot of expensive, easily fenced photo gear!" For fully insured shipment by aircraft or whatever, there's no better way to go, but for field use with less than an army of assistants, I would prefer even an Army surplus knapsack.

Slightly more useful are the fitted cases offered by Miida. These cases, of a plastic material, are durable, hard-sided, and contain snap fittings for one or two cameras, plus much room for lenses, film, flash units and other gear. Shoulder straps and side opening make this type of case easy to use, while the outside film and filter pocket adds to handiness. Pro cases, which look something like overwide briefcases, can also be handy if they have a drop side allowing you to get to the contents without setting the bag down. All camera bags, even those that don't look like camera bags, should be carried on your person at all times, or the contents should be heavily insured—inconvenient for sure, but a lot cheaper than constantly having to replace stolen equipment, which is just what will happen if you leave things lying around in public.

Also in the Miida line, there's a semisoft bag with a removable inner compartment (depending on the overall bag size, the inner compartment can hold one or two cameras of almost any size, and a specially lined outside film pocket. The lined outside pocket prevents airport X-rays from ruining your film. Yes, I know airlines swear that film fog can't happen under the low levels of radiation they use, but reports that such fogging does occur keep coming in. Protection is handy and cheap, certainly hundreds of times cheaper than reshooting sequences or letting it all go in a haze.

From here, it's a move to whatever manufacturer makes a case that turns you on. Neither Miida nor Halliburton have a lock on the field. Spiratone offers several good cases, fitted and unfitted, at more reasonable prices than we've come to expect

in photo equipment. Their soft-sided case, which goes for around $15, has room for huge amounts of gear. The biggest problem here has been a strap weakness at the point where the straps are riveted to the case. Spiratone has now slung the case inside the straps, so rivet points shouldn't give way, though any cobbler can fix the problem should it occur.

Then there's the old, handy knapsack. More and more professional and amateur photographers seem to be using these handy little bags. Generally, leaving the lenses in their original cases (soft or hard) and filters in their packing will provide more than sufficient protection in any soft-sided case, including the knapsack. At least one of your cameras should be around your neck at all times, so they won't be bouncing, jostling and chipping off paint inside the bags. And, boy, is the price right for knapsacks! Most surplus stores will sell you such a bag for about three bucks (sometimes less if the manager has an over-supply, seldom more than four dollars). Add a pad to the shoulder strap you make from the shoulder harness, and that's it. Good for years of use.

Film cans which snap onto the carrying strap of your camera seem to be in at the moment, though you won't be able to use them if you've bought the extra-wide strap I advised. Equipment snobbism provokes snide remarks at those of us who retain the idea of taping old film cans—or the newer plastic cans—to our camera straps. When you think of the savings, though, at $.50 to $.75 per can, when anywhere from six to forty of the things might be needed, you smile.

The new plastic containers for film are even better field holders, as they are less likely to get dented or to corrode. And these containers can easily be taped to the widest camera strap. Sure, it looks awful, but it works and keeps your extra film handy. If the looks bother you, you can always get a cloth tape that matches or contrasts with your strap. Or you can return to your friendly surplus store and pick up a canvas strap, using that as the basis for a film bandolier. Just make sure you leave enough room to remove the film from the canisters as you tape them to your strap. About a can's distance from lid to bottom should be fine. Old military bandoliers, the real ammo kind, can also be used as film carriers. Each pouch will hold two rolls of 35mm

with no crowding, and three with some pushing. Surplus binocular cases, deerskin pouches, cartridge belts, all offer good film-carrying capacity, and the cartridge belt also offers you a place to hang a canteen on those hot days. Thus there really is no reason to spend a lot of money for zipper-top film carriers.

If you use a tripod, sooner or later you'll want to have a long cable release or air-bulb release so that your punching of the shutter button doesn't contribute to camera shakiness. For short distances, up to about three feet, cable releases are very popular. Beyond that point, friction problems can occur and you'll probably have to revert to the air bulb long used by portrait photographers. Available in lengths up to 20 feet, air bulbs can allow you to get started in remote photography with ease and at low cost. Of course, the biggest problem then is trotting over to the camera and getting it set for the next shot.

That's where our next accessory comes in. The motor drive, available with several brands of camera as an optional accessory, and as part of a separate camera with other brands, can usually be fired in single shots or on continuous feed. For most photography, single shots will serve very well. Even then, operation is considerably faster, as it's no longer necessary to fool with the shutter-cocking /film-winding lever. Everything is done for you. On the continuous-feed phase, the camera keeps shooting until you lift your finger from the button or run out of film. It's easily possible to learn to fire one shot at a time while the camera is on continuous-feed, just as a good BAR rifleman can—or could when Browning Automatic Rifles were still in use—fire a single shot when needed. But it's a lot simpler, and much easier on film supplies, to use the single-shot setting unless the situation demands continuous feed. A camera set on "C" all the time invites wasted film every time you brush against the shutter release, and an unnoticed hard brush can wipe out a roll of film in just seconds (at 3.5 frames per second, you can get 10 seconds of action, or waste a roll of 36 exposures). Some of the ultra-high-speed motor-drive cameras will take up to nine frames per second!

Almost any sort of action photography can be enhanced by the use of motor drives, though some kinds are more likely to receive full benefits. You're not going to gain much by taking serial shots of a miler at a track-and-field meet (though shots

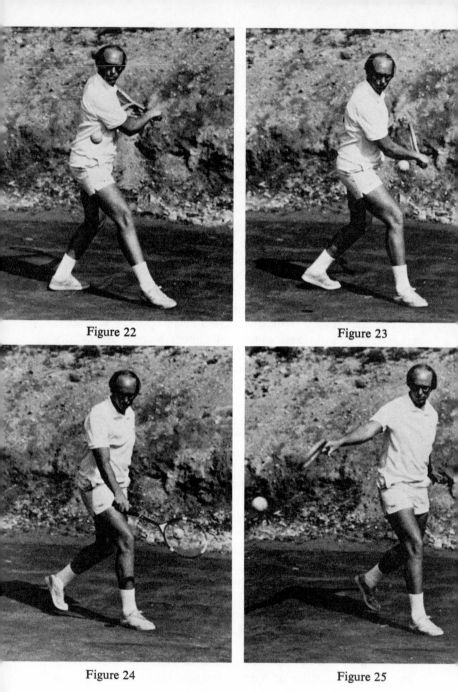

Figure 22

Figure 23

Figure 24

Figure 25

Figures 22 through 25. This is an example of the type of action you can capture with a motor drive. The photographs above were taken at 3½ frames per second.

of a pole vaulter, done serially, can be very interesting). At a motor race, though, whether you're shooting cars, motorcycles or karts, the benefits can be enormous. Action is too rapid at most events for you to catch everything of interest, if you have to cock the camera after every shot. Too much can happen in that short interval. If you click them off without having to twitch, you'll be able to do a better job of keeping up with the event through your viewfinder. You'll still find yourself missing what could be the best shots, even with a motor drive, if you don't shoot selectively and with care—everything doesn't happen at three or nine frames per second. You could miss the shot of a lifetime if you fire away without forethought.

Is the motor drive worthwhile for the average amateur photographer? That's an almost impossible question to answer without having access to that amateur's bank balance and credit and income records, but in most instances the answer would most likely be no. Many, many pros get along without motor drives and turn out some really fine race photos. Others start right out with the fancy stuff and still manage to turn out lousy pictures. Everything depends on the use and the user. Motor drives can make the job easier, but they alone won't replace skill and talent. Like all accessories, motor drives are made for a purpose. With skill (that nasty word *practice* comes to mind once more) the motor drive will improve your high-speed action photography. Without skill, it won't do much beyond saving the tiny bit of energy needed for you to wind the film forward—and it may cause you to louse up shots you'd otherwise have gotten.

If you can afford it, and will work to develop your skill, the motor drive is a help, but it's no panacea for those missed shots.

Motor drives bring to mind related accessories for some cameras. Such things as bulk-film backs, holding 250 or 800 frames of film, remote switches, automatic camera controls so that servos will do the adjusting on your remotely fired camera as light levels change. All of these things are useful in their places, but in general they are for highly specialized photography and would do nothing for most of us, that is, beyond running expenses up to luxury levels.

Consider the cost of a bulk back, added to a camera, with a motor drive and servo finder dropped in. The back (for a Canon

F1) will run you well over $200, possibly as much as $300. The motor drive will tap your wallet to the tune of over $500. The camera will cost between $500 and $600, or more depending on lens choice. Then add a servo finder for some $250 and start looking at remote-control units at near $20. Your total can vary from about $1,370 to $1,600 or more, without including a single extra lens. Add 15 to 20 per cent for Nikon equipment and 100 per cent for Leica. Nice, but do you need all that? No. Even professionals take years to accumulate that much gear, and are sorely tempted to not tie up that kind of money in a system which will require at least six other lenses and two more camera bodies. A few do, and they certainly look impressive when you see them at an event. What's really impressive, though, is the feeling of joy you get in realizing that those three motor-drive cameras aren't slung around your neck, because each motor drive weighs a hair more than the camera, making three motor-driven cameras equal in weight to six cameras! A real pain in the neck.

Flash units we've mentioned several times already. Today there's a lot of flashing available for less money than ever before. Electronic flash can help cut overall flash costs quite a bit—the original price is steep, but the savings in flashbulbs over the years is huge. Flash is useful as fill lighting, and can also be used to at least partially wash out the odd colors fluorescent lights produce on color film. For poorly lit indoor events, flash is essential for clear photos. I hesitate to recommend any one type of flash for two reasons: In some situations focal-plane bulbs will do a better job than electronic flash; electronic flash is in the throes of great changes, with the automatic, thyristor controlled units now making up a large part of the market.

Unfortunately, the helpfulness of flash seems to slow to a crawl when the photographer begins to get away from the normal lens, into telephotos and wide angles. With the telephotos, the flash may not be strong enough or focused well enough to get enough light to the subject for the job at hand. Wide angles may not be fully illuminated because the lens covers a wider area than the flash illuminates evenly and well.

For your medium telephotos, a sort of cure is to be found. With wide-angle lenses, the best bet seems to be to buy a flash specially made for use with WAs, or to use two flash units, spaced

a bit apart at the camera. In both cases, experimentation will be required to determine the correct guide numbers when in use.

The cure for telephoto-lens light drop-off is simple: Make a tube of white cardboard, thick enough to be opaque, and then tape that tube over the front of the flash in order to form a "funnel" for the light; this will give you a tighter beam from your flash. As we said, it will require experimentation to get the light-fall correct at various distances for spread and intensity, but it will provide more light on the subject at moderate distances than will just the flash head. Limits are still there, but they are moved back 20 or 30 feet.

Flash judgment is a thing acquired over the years in action photography. With electronic flash, you must use X synchronization, which is equivalent to about 1/45 or 1/60 second in shutter-travel time. For most purposes today, electronic flash is the way to go. The extra high speed of the emitted light—from about 1/750 second up to 1/2500—will stop action at most indoor events, and the extra light will fill in shadow areas. Still, for fill-in flash, bulbs sometimes make more sense than does electronic flash. Focal-plane shutters will frequently couple with focal-plane flashbulbs at speeds up to the top of the camera's capability. In other words, if you've got a 1/1000 second top shutter speed, a focal-plane (FP) bulb will be in synch at that speed. Your electronic flash will couple only at the lower speed, and if ambient light is strong enough you'll end up with ghost or after-images on the film. On the Canon, and on most other cameras, the speeds that couple with electronic flash will not couple with FP bulbs. That's about the only limitation on the use of FP bulbs—which, by the way, you'll probably have to go to a photo store to buy, since few drugstores seem to stock such exotic gear.

FP bulbs, then, make better fill flash units and are handier in high-speed situations where the light levels are relatively high than are electronic flash units.

In low-light levels, where the flash will be the primary light source, electronic flash will do the best job at lowest overall cost.

Flash guide numbers can cause a lot of problems, particularly since most of those provided with flashbulbs and electronic flash units tend to be optimistic. To determine the correct guide number for your flash unit, look for an average indoor subject, in an

average-size room. One or two people or medium-colored objects in the average living room will do fine. Measure a distance of ten feet from your flash unit to the subject, and then shoot a series of pictures at half-stop intervals (most cameras have click stops—unmarked—at those half stops). From $f/4$, the half stops will be $f/4.7$, $f/5.6$, $f/6.7$, $f/8$, $f/9.5$, $f/11$, $f/13$, $f/16$, $f/19$ and $f/22$. Record each lens opening used. Then have your ASA 64 film processed and project the transparencies, or use a strongly lighted viewer or light box and magnifier to select the ones you like best. Check the $f/$stop you used to make that picture against your records, and multiply it by ten. That's your guide number.

Now, whenever you need to know the proper exposure for flash, all you need to do is divide your guide number by the distance from your subject and dial in the resulting $f/$stop. At ASA 64. The same results can be gotten for any speed film by simply shooting a roll as above, with the speed film you wish to use, whether it's ASA 25, 50, 160, 200 or 500.

8.

Film

Film is essential to every type of photography, and the choice of films will strongly affect the quality and style of your resulting photographs. In fact, choice of film in many situations can decide whether or not there will be any photograph resulting at all.

For our purposes, we'll discuss only those films of primary interest to the action photographer: black-and-white negative film; color-transparency (slide) film; and color-negative film. There are many other types for a variety of uses, ranging from the artistic to the industrial, including infrared, of which you already know my opinion.

Since black and white is generally considered the easiest and simplest of all films, we can start there. First, good black-and-white photography is no simpler—nor is it less creative, attractive, or generally pleasing in any way—than is color work. Different, yes. Better or worse, no.

For 35mm cameras, black-and-white film comes loaded in cassettes, with, most often, 20 or 36 exposures on each *roll* (a word I'll now replace with the more correct but less wieldy *cassette*). The film consists of a plastic base with several layers of chemicals, which perform several different functions. Of importance to us is the reaction of the film to light. Slow films have a slow reaction time, or, in other words, require a lot of light to react (in this context, a lot of light would come from a tiny flashlight). Generally listed as the ASA 25–50 films, slow films are great for bright days on beaches, over water, in snow—that sort of thing.

The ASA rating means only one thing: Film rated at ASA 50 re-
acts twice as fast to light as film listed at ASA 25. A film listed
at ASA 400, such as Kodak's Tri-X, reacts five times as fast as
the ASA 25 film (ASA 25 to 50 to 100 to 200 to 400). Kodak,
Agfa and Ilford all make films in this slow range, with Agfa's
Isopan IFF rated at ASA 25, Kodak's Panatomic-X at ASA 32,
and Ilford's Pan F at 50. This film, besides offering good control
at extremely high light levels, also offers very good shadow gra-
dation, clarity in detail, and almost no visible grain in even the
most immense enlargements. Excellent choices for bright days,
but once the sun slides away and the clouds come out to play,
run it out of the camera and slip in something at least in the
middle-speed range, or you'll find yourself doing all your picture
taking at $f/1.4$ and $1/30$ second, which isn't all that great for ac-
tion photography.

Medium-speed films include films by the above three companies
and GAF. Agfa's Isopan ISS (ASA 100), GAF's 125 (ASA
125), and Ilford's FP4 and Kodak's Plus-X-Pan (both ASA
125) offer good exposure latitude, meaning you'll still get a
large number of usable pictures even if you goof by a stop or
two on your metering, and greater speed for those mildly cloudy
days prevalent in many parts of the world. Tonal gradation is
still excellent and grain is quite fine under most conditions, allow-
ing relatively easy enlargement to about 16 by 20 inches, if the
film is perfectly exposed and developed.

Fast films in the black-and-white end of the field are those rated
at ASA 400, now an implied industry standard since GAF dis-
continued its 500. Agfa has its Isopan Ultra ISU, Ilford has
MP4, and Kodak has Tri-X-Pan. Again, these films give you
great exposure latitude, allowing a free hand with the meter, up
to one or two stops in each direction, depending on conditions
(spot-on exposure will give much finer results, of course). These
are great films for high-speed photography in moderate-to-dim
light, and for any kind of photography in very dim light. Graini-
ness increases a bit here, but remains (reasonable in size and is
sharply defined,) which tends to make it less noticeable. Detail is
good, and shadow gradation as well as tonal gradation is sur-

prisingly good. My standard black-and-white film for years has been Tri-X, with a neutral-density filter used to cut the speed when necessary for control. Such simplification reduces problems caused by having the wrong type of film in the camera, makes bulk-film purchasing easier, and minimizes mistakes if you process the film at home. My choice has been Tri-X for several reasons: first, I like the results it gives; then, when shooting motorcycle events in the dark woods abounding on this continent, it's not always possible to locate film produced by Agfa or Ilford, yet Kodak film can be easily found in any part of the world, and in virtually every drugstore in the U.S. Enlargements of the entire negative to 11 by 14 inches are simple with Tri-X, and if all is perfect, half-frame enlargements to 16 by 20 inches can sometimes be made!

Super-fast black-and-white film is the stuff used to take pictures of black cats in coal bins. Only two companies are into this rarefied area: Agfa, with Isopan Record; and Kodak, with Royal-X-Pan. The Agfa film is nominally rated at ASA 1000 and the Royal-X-Pan calls for ASA 1250. These films are truly for extreme conditions, and I doubt any of you will ever need to use them. Try flash instead. Shadow detail ranges from fair to lousy. Definition is poor. The degree of enlargement possible is relatively small. But if there's no other way to get the picture, these films will give you some kind of film image.

The chemistry in black-and-white film is a bit less complex than the chemistry in both types of color film, which may be why company names differ somewhat when the color films roll around. Still, you've certainly got plenty to choose from, both with color-negative and color-transparency films. We'll start with color negative, as that's the type most amateur photographers seem to consider "color" film, and with good reason: The negative process allows the processor to make corrections when there is a metering and exposure goof of a degree that would ruin any transparency.

Color-negative film is easier to use, since minor exposure goofs can be corrected. The range of ASA ratings is relatively small, though there are several companies in the field: 3M's Dyna-

chrome is rated at ASA 64; Agfacolor CNS comes in at ASA 80; GAF's Color Print Film is also ASA 80; Kodak has Kodacolor-X at ASA 80 and Ektacolor-S at ASA 100.

These are all daylight films, for use in light that comes close to average daylight in color temperature, or with blue flash. Grain and color rendition vary from brand to brand, and the brands that please me are just as likely to displease someone else. Color judgments ranges from highly subjective to explosive, so I'll make no recommendations here, since there's no film in this group I use very often (most editors prefer transparencies). Try at least one roll of each brand under different conditions and judge for yourself which gives the most pleasing effects on your walls. Try to make your judgments from prints no smaller then 5 by 7 inches, rather than those crummy little drugstore prints most people get. Another point to keep in mind: When having any negative film processed, whether color or black and white, in-sist on getting contact sheets of the entire roll(s) rather than a whole mess of small, but expensive, prints. (Even most camera shops will supply you with the small prints.) The industry seems to labor under the idea that every person has some overwean-ing desire for photos too large for a wallet and too measly for an album or a wall. Don't go for it. If you can't get contacts from your regular processor, find another.

Viewing a contact sheet through a magnifier will give you a good idea of just what pictures you wish to invest more money in, which will result in pleasing prints of display quality. You'll also be able to instruct the processor in cropping and lining the print up on the paper. You'll spend much more on each final print doing it this way, but you'll save a fortune in costs for prints that no one can see.

Color-negative film is easier to use, since minor exposure goofs nine or ten chromes on the market—most films with a name end-ing in *chrome* are slide films: Agfachrome; Fujichrome; Koda-chrome. Of course, there are some without the name, such as 3M, GAF 200 and GAF 500. ASA speeds range from a low of 25 (Kodachrome 25) to a high of 500 (GAF 500), with many intermediate speeds. At least once a year, one of the photo-graphic magazines will do a test on all, or most, of the available

transparency films, commenting on color saturation, availability, processing availability, grain size and color rendition.

Generally, improvements from year to year are minor, though they really add up when you compare the qualities of a film used now with one ten years old. As things presently stand, the finest grain and skin tones, and the most natural-looking greens, come from Kodachrome 25. Though the ASA of 25 is a bit slow for much of the action we're seeking, this film has for years been the standard by which all others have been measured (under the name Kodachrome II). Any change in that status would probably stun the photographic community, industry and nonindustry alike.

Moving up one stop in speed, we find Agfachrome CT 18 and 3M rated at ASA 50. The Agfa film has moderately small grain, with very clean whites and a bit wider exposure latitude than is usual in slide films. Overall color rendition is a bit warm, but only very slightly so. Agfachrome 3M offers small grain, contrasty skin tones, excellent orange and red rendition, with clean whites.

Of the above two films, the home processor would only be interested in 3M, as the other two must be lab-processed, by Kodak and Agfa or their licensees. Kodachrome 25 is the most widely available. Agfachrome can be found in almost any camera store in the country, while 3M pops up in more unusual places, such as chain stores with camera departments, an occasional supermarket, and a few camera stores.

Moving to a slightly faster film, we find GAF 64 at a rating, of course, of ASA 64. Grain is fine here and blues tend to be especially rich, as are reds, while skin tones go very slightly to the yellow. Latitude is quite wide, well above average. Ektachrome X and Kodachrome 64 both offer ASA speeds of 64, are produced by the same company, and would seem to be very similar. They're not. Ektachrome X is grainier than Kodachrome 64, gives slightly cold skin tones (a shade to the blue side of the spectrum), clean but cold whites, and warm oranges and reds. Kodachrome 64 offers mildly warm skin tones, clean whites, and rich, natural greens, with a grain not much more in evidence than with Kodachrome 25. The best way to locate your preference is probably to try a roll or two of each on a variety of subjects. Film with

the lower mid-range speeds such as ASA 50 and 64 are very handy for action and sports photographers because they allow a great deal of control on extremely bright days, but still have enough speed to let you use the end of the roll as the clouds and mists move in.

For darker days, or high-speed action, the only true mid-range film is Fujichrome R-100, with an ASA of 100. A full two stops faster than Kodachrome 25, R-100 offers small grain, fine skin tones, clean and slightly warm whites, and natural-looking greens. Latitude is reasonably wide. Availability is good at most camera stores and many chain stores.

For really high-speed action, or those dim days when the drizzle won't stop or the fog is moving in, GAF and Kodak offer a total of three outdoor films. Kodak's offering, High Speed Ektachrome (ASA 160) is the slowest of the three, though an extra buck to the processing lab will bring you "official" Kodak pushing to E.I. 400, which returns slides of quite good quality. Grain is moderate, blues are particularly rich, whites are clean, and skin tones seem to be natural-looking. Of course, these qualities decrease a bit when push-processing is used, but not much at E.I. 400. A few nuts have used the film at E.I. 1,000, and I hope never to see the results, for they must be terrible! Latitude isn't very wide, so metering within $\frac{1}{4}$ f/stop is almost essential, and right on is even better.

GAF kicks off its high-speed line with its ASA 200 film. Grain is moderate here, greens tend to be brownish, whites aren't so white since some yellow creeps in, and the oranges and reds are really fine. One step up on the speed meter, GAF has the fastest color film produced by anyone: GAF 500. This film has grain that can easily end up looking as if prints were made through shattered window glass, and it has a bit more contrast than is easily acceptable. Skin rendition goes a bit to the red, and the whites pick up a magenta cast. Push-processing to E.I. 1,000 is possible, but the results are awful, with a magenta cast that is quite heavy in the whites, even more contrast and golf ball-sized grain. In general, GAF 500 is a film to be used only when extreme high speed is the only way to get a color shot.

As you'll most certainly have noticed, my comments on film

quality become more derogatory as the film speeds increase. This happens with black-and-white film but is more likely to show up at lower speeds in color film because of greater complexity in manufacture. No fast film is, or at present can be, as fine-grained as a slow film. Period. Still, modern technology has improved films to the extent that almost anyone can obtain pleasing pictures with even the fastest films. What is here called coarse grain doesn't necessarily mean that the grain showing up is objectionable in standard photography, and use of these high-speed films can, and often does, mean the gaining of a recognizable image where the use of slower films would produce only a blur, if you were lucky, and less if you weren't. Still, your best bet would probably be to start with the slower, finer-grained films in both black and white and color. If the films you choose—my recommendations would be Plus-X-Pan and Ektachrome X, or the nearest equivalent from companies other than Kodak—aren't fast enough for the uses you most often intend, then move up a step or have the processing changed. Some people get excellent results shooting Plus X at an ASA rating of 200 to 250, and adding 20 or 25 per cent to development time.

When at all possible, I feel it's easier and generally gives better results all round to get used to just one color film and one black-and-white film. For that reason my cameras are always loaded with Tri-X and High Speed Ektachrome. In cases where this causes a loss of control, where I want to blur wheel spokes or arms and legs but can't drop shutter speed quite enough, I prefer to use a neutral-density filter to reduce the amount of light reaching the film rather than changing the film. Again, this cuts down on complexity and helps to prevent mistakes. You can carry a 4X-rated ND filter (a two-stop drop in film speed, in effect) and film with an exposure index, as I use it, of 400. (The Ektachrome is shot at 400 to further simplify matters, preventing any problems in case I should forget to change film-speed data on my cameras and meters—just another way of getting rid of complications.) Effective film speeds are thus cut to 100, which will give enough light action for moderate light, and will still allow a great deal of control under bright light. When the sun sinks or the rains come, all you need do is pop off the filter, drop it in

your pocket—after putting it in its case—and keep on shooting. For mid-range shots a 2X filter can be carried, since the different density of the filters is readily apparent in any side-by-side comparison, making them very difficult to mix up. This gives you a choice of film speeds ranging from 100 to 400—certainly enough for all but the most extreme conditions. Such filtering will allow the use of flash at much closer distances than otherwise might be possible, too. All kinds of little benefits.

Indoor color films add to the list of chromes which can be used in action photography. Kodachrome II, Professional Type A is balanced for photofloods putting out light at a color temperature of 3,400 degrees Kelvin. This ASA 40 film has fine grain and a wide exposure latitude, which makes it quite handy indoors. High Speed Ektachrome, Type B, offers tungsten light balancing (3,200 degrees K) and an ASA of 125, with moderate grain and a close-to-normal look when shot indoors in artificial light other than fluorescent. It actually works quite well with some types of stadium lighting and with most normal house lighting.

That about covers the types of films presently around, films that come close to being universally available, at least with a bit of searching on your part. There are others, but there seems little point in covering films which now show no signs of being available almost everywhere. If you get used to a film when living near Chicago, Los Angeles, New York or some other major city, and then find yourself out of your favorite when in a rural area, have fun. With those mentioned above, nearly any small town or village will be able to supply you.

Other film tips come to mind. Considering how much film costs these days, photography can get awfully expensive when you start running through more than a couple of rolls a week. A partial solution to this problem, one that takes only a small original investment and a very few minutes of your spare time, is to roll your own and save a lot over the years. The savings from rolling film into your own cassettes from 50- or 100-foot-long bulk rolls can be very substantial, approximating the savings realized by rolling your own cigarettes, but without the related health worries. Basic requirements are simple. You'll most likely

already have the changing bag, so all you'll need is a bulk loader (cost ranges from about $6 on up to $40, depending on features: the six-buck model does just fine; I've been using my present one since 1968); 100 feet of your favorite film; about 20 film cartridges (this varies widely depending on how much film you expect to shoot at any one time); and a roll of tape ½ to 1 inch wide. Total cost shouldn't be over $20 the first time out, excluding the changing bag: loader—$6; film—$9; cartridges—$4; tape—$.75. Result: 19 rolls (36-exposure rolls, at that) of 35mm film. Savings the first time around should be at least $8! After the first purchase, savings grow considerably, with cartridges pro-rated over *no more* than three uses before discard. Thus nearly $30 worth of film will cost you less than $10. It's a marvel how much you can save this way. Percentage savings are much greater for black-and-white film, but with 100 feet of High Speed Ektachrome costing about $30, your cost per roll of film would be about $1.65, for nearly a 50 per cent saving on each 36-exposure roll of color film! That's $30 a load (100 feet) you'll be saving.

More money can be saved by doing your black-and-white film developing at home. The chemicals are cheap, and your major equipment purchase would be a tank and a few reels at around $16 (stainless steel) and a thermometer costing from $8 to $15. We won't cover home processing here, simply because there are dozens of books, most of them quite good, already covering the subject more intensely than we could, not to mention the numer-ous technical, semitechnical and not very technical brochures and magazines dealing thoroughly with every type of darkroom work. The only word worth adding is that negative film processing is simple, quick, and does not require darkness for anything but loading the film onto the reels and the reels into the tank, a job quite easily done in a changing bag.

Home processing of color-transparency film is not a great deal more complicated, though there are many more steps and the temperatures are critical. It can be done with just a bit of atten-tion to detail and plenty of time. In fact, the time wasted is my biggest objection to home color processing. Most instructions list a procedure that takes about forty-five minutes, but you'll find that bathroom processing of color-reversal film will run you closer

to two hours per batch, which just ain't profitable if you're running only two rolls of film in each batch. Still, you might give it a try. It can be fun.

As we said earlier, the best bet for most photographers, those who don't need the special effects of a variety of films, is to standardize on one black-and-white film and one color film, and stick with those whenever possible. Look for a film with all the qualities you want in speed, color rendition, grain size and ease of purchase—and go to it.

9.

Outdoors with a Camera

Much of your action photography is going to take place some-where in the outdoor world, unless you emphasize only indoor sports. Most of what is needed for the outdoor action photog-rapher will come under the heading of equipment protection and care rather than picture-taking technique and special equip-ment.

The same equipment for use indoors will make the trip out-side: camera(s), lenses, tripod, flash unit, cable releases, etc. Lighting outdoors is often uncontrollable, though there are times and places where flash and reflectors or reflector boards can come in very handy. When that time comes, it's easy to be pre-pared.

Your photoflash units will be ready to go, of course. Fully charged batteries, or an extra, fresh, set (if your batteries aren't the rechargeable kind) should be on hand. All brackets and flash (PC) cords should be ready to go, and untangled.

When will you need all this flash stuff outside? Well, we've mentioned earlier that the use of fill-in flash can improve photo-graphs, while stating that many times FP (Focal Plane) flash-bulbs may do a better job. There are still times when the elec-tronic flash will do a better job. Night is, naturally enough, one of those times. There's not enough natural light around to cause after-image effects, nor is there enough light to give you anything but special-effect photos. At such times your electronic flash is indispensable.

More complex are the moments you run into in bright overall light where shadows are so deep that there is no detail in half of the photograph. One side is perfect; the other is totally obscured by shadow. You'll find this happens a few times before you begin to notice the quality of light that causes it. After you start to notice the quality of light, you'll start to waltz about looking for the proper angle to get full lighting on all important surfaces before clicking the shutter. Movement works pretty well sometimes; at other times it's a total waste; and most times it will only do the job halfway. When the light falls too much from one side, the only way to get a fully covered surface is to move the subject so that all planes get equal, or almost equal, illumination. Of course, in action and sports photography, you're severely limited by your subject. You can move, but the miler out on the track is liable to bend your beak if you ask him to turn around and run the other way. Again, situations limit you as to the corrective techniques you can use, but the only option you now have is to move the light. Fill-in flash can be very handy in such instances. Usually there's no way you can line up a reflector or reflector board to drown out the shadows without driving yourself, the contestants and other photographers half crazy. Use fill-in flash in such instances, but try to use it so that the competitor is not disturbed.

Reflective surfaces come in handy at those occasional events where movement isn't excessive, or in staged action shots, or in grabbing fully lighted shots of animals photographed from blinds, and so on. Such fill-in light reflectors are also handy when making pit shots, grabbing human interest stuff at a game or meet, and putting some flash on the action shots in your photo story. The easiest type (and the cheapest) is simply a sheet of white artist's board with a smooth, but not glossy, surface. Getting a bit fancier, you can crumple a piece of heavyweight aluminum foil the same size as the board—actually, you should allow a few extra inches on each side to allow for loss of size when crumpling the foil—and then tape or glue the foil to the board. Try it both ways and see which type of light you like best. Three half-inch dowels about six inches longer than the widest or longest dimension of your reflector board can be tied, screwed or taped to form a kind of easel to hold the board in the proper position.

Use small brads driven into the dowels to keep the board on the easel. A slight bend on the ends of the brads will keep things from slipping. A board reflector can be adjusted to nearly any angle except overhead, and can quite handily add fill-in light on one side of a photograph. It's also a great deal cheaper than buying a reflector umbrella and light stand!

That about covers the lighting control you can expect to have while in the field. Portable and unobtrusive, the above stuff can be a big help in some situations.

When the situation doesn't allow use of auxiliary lighting, you'll have to go with what the sun and your movement can provide. When that happens, start searching for special angles. Take advantage of the fact that one side of the subject will be poorly lighted by shooting the type of composition that makes such lighting a creative aid. Catch the sun just over a flailing forearm, or just bursting from behind a runner's head. Let the shine of light through a frame of leaves silhouetting the subject add to your photo. Shoot from ground level, letting the sun make an over-exposed halo around the main subject, fading out any distracting secondary subjects and background. *Use* the light, no matter how bad it may seem at first, and your pictures will be as good or better than some of those you see in major publications.

Outdoor photography takes a greater toll on equipment than does indoor work, and action photography is the roughest of all. You never know what's going to happen to those expensive tools next. Rain. Sleet. Snow. Mud. Mire. Dust. Sand. Contusions and abrasions, both to your hide and the camera's finish, become almost everyday occurrences. General camera care becomes even more important than under normal conditions. Like anything else invented and produced by man, cameras are imperfect, and are also subject to normal wear and tear over the years. Proper care is essential if you want to get the most use for the longest period of time.

Often, proper care consists of doing as little as possible to the camera, but there are a few things that everyone should take care of whenever necessary. The lens will occasionally need cleaning. Make those occasions as far apart as possible, however. Cleaning a lens more often than necessary does more harm than good, since special coatings can be worn off more quickly with all the

rubbing. When lens-cleaning time does roll around, use a proper lens-cleaning tissue—buy it in a camera store, not a drugstore, where you can only get the hard-coated stuff for cleaning eyeglasses (never, never, never use eyeglass tissue, because eyeglasses are made of much harder-surfaced glass than are camera lenses). If needed, a drop or two of a lens-cleaning liquid such as Kodak's aptly named Lens Cleaner will do a good job of removing heavier stuff. For everyday cleaning use a blow brush (bulb type) or canned air available from camera stores to remove dust. For heavier dust deposits, a very soft brush—camel's hair is the most popular—should be used. Dust removal is important, for those tiny flecks can show up on your negatives as large, out-of-focus blobs.

Dirt on the camera body can easily be removed with a cotton swab dipped in rubbing alcohol, though most grime should come off when you brush the camera. Dirt does have a way of building up, however, so whenever needed, get out the alky and the swabs. Another cotton swab, and more alcohol, will work fine on the viewfinder window(s), and the rangefinder and meter windows (if you're using a rangefinder camera).

Now remove the lens and take a peek inside. Blow off and brush off the back lens element and any crevices which might have collected dust, paying attention to the screw or bayonet slots on your lens mount and the back of the lens. Inside the camera body you'll see the mirror, which makes all the noise when a single-lens-reflex camera is fired. The best way to dust this off is to use an ear syringe, canned air or a photographer's bulb. If absolutely necessary, a soft camel's hair brush can be used, but usually it's best to leave well enough alone. Too much pressure will mess up the mirror and its related systems. Where the mirror is concerned, very little is too much, so whenever a brush is used, be almost excessively gentle.

Now replace the lens and open the back of the camera, keeping the air bulb and brush close at hand. First, up-end the camera and give it a gentle shake so that any loose film chips drop out. Now blow away any dust. As a final touch, use the brush to get out any dust and chips still inside. Under *no* circumstances should you touch the shutter curtain! That curtain is made of extremely thin fabric or even thinner metal (titanium). It is made to take

the shock of being slammed open and closed at extremely high speeds, but it will not live through even the gentlest poke with a finger. So don't poke. Repairs to shutters are *mucho* costly.

Some people recommend using a vacuum cleaner, set on suction, to pick up dust from a camera. My feeling is that they're nuts. There's just too much delicate stuff and sensitive hardware in good cameras to fool around with household cleaning gear with no control over a suction powerful enough to pick up tenpenny nails. Just imagine how you'd feel if your vacuum cleaner sucked the shutter curtain partway out of your camera. Another instrument that shouldn't be used to clean a camera is the human mouth. Unfortunately, our breath is heavily laden with moisture, which is not the greatest lubricant for precision camera parts.

We're taking it for granted that you manage to keep your fingers off all the glass surfaces of your camera. If you don't, the only cure is immediate removal of the fingerprints with lens cleaner. If you don't get the prints off, you can almost count on having an etched lens when the acid in your skin oils gets to work on the coating of the lens.

Camera care falls under indoor as well as outdoor recommendations, but the tendency for the gear to accumulate dirt is multiplied by being out in the air.

Camera care outdoors includes a few things besides cleaning. Basically, these come under the heading of weather protection, since rain, cold and related factors can do weird things to any piece of precision machinery. Add to this the fact that even the best cameras aren't very well sealed against dust and water, and you come up with some possible problems.

The rain problem can be handled in two ways—one expensive, and one cheap. Primarily, the expensive solution means you'll buy an underwater housing for your camera. These things start at about $40 and move upward quickly. They also make almost any camera clumsy to handle. Protection from water is great down to 100 or more feet, but a lot more than is really needed even in the most severe rainstorm.

Since some sort of protection is good, the cheapest way seems to me the best. Get a large sandwich bag of clear plastic and a rubber band a hair smaller than the outside diameter of your lens. Slice out the end of the sandwich bag so it's open on both ends.

Now place the camera inside. Take the rubber band and slip it over the bag and the lens, just back of your sunshade attachment point, keeping the plastic off the front of the lens.

This plastic bagging allows easy access to camera controls, reasonably free access to focus rings and diaphragm controls, and allows you to load and empty the camera without removing the bag by simply flipping the works forward. Cost should be about a nickel, maybe a dime if plastic and rubber prices go completely out of sight (highly probable). At the same time, the greatest amount of rain water will run off the camera instead of into it.

Not only does a camera require more care in winter, but you'll find film problems mounting as the temperature takes a dive. First, though, any camera to be used extensively in very cold weather should be thoroughly checked over by an expert repair man. This is not a thing which can be done at home, since the shutter mechanism must have all, or most, of the lubricant removed to prevent sticking, as the oil thickens from the cold. Since we're all using single-lens-reflex cameras, we're all caught in the same bind. Focal-plane shutters react very poorly to cold weather.

Protection of the camera is pretty much the same as for rain, except for one thing. Keep an extra, larger plastic bag and tie on hand for those times you enter a warm building from the cold, cold wastes of wherever. Just before you enter, place the camera inside the extra bag and seal it as tightly as possible. When you're ready to come out again, the outer bag will be coated with condensation. Which is good, since that moisture will now freeze on the bag instead of the camera. When the camera has reached operating temperature, remove the extra bag and go ahead with your picture taking.

Static electricity can drive you crazy at any time of the year if lightning makes you nervous, but it's truly the bane of the winter photographer. If you're set on using a motor drive on winter days, use only the single-frame mode. When you rewind film, do it gently and slowly. Taking this little bit of care will prevent what seem to be lightning streaks on your pictures. In extremely cold weather, be careful about handling film as you load your camera. Though the plastic emulsion backings are normally quite

flexible, they tend to get brittle in extreme cold. Snapping off a film leader is not the greatest way to start a day of photographing skaters, skiers and assorted snow lovers.

Have some care for yourself too. Remember all the words which have gone before on camera shake. If you're cold to the point of chattering teeth, go inside and warm up before trying to take decent photographs. Wear enough clothes to keep warm even if you do feel a bit like an actor stuffed into a gorilla suit. Look for gloves, not mittens, to keep your hands warm. Shooting gloves, with their thinner trigger finger, are preferable to mittens, which you have to remove whenever you fire a frame or adjust the camera, so your hands end up twice as cold as they do in gloves, which are less efficient as retainers of heat. If you have to use mittens, see if you can't find a pair of very light nylon or silk (silk is preferable) gloves to wear underneath. Sometimes, when the temperature dives and wind zips by, your bare fingers might actually stick to the cold metal of your camera.

When doing outdoor photo work in warm weather you'll often want to divest yourself of the gadget bag and all but a few of the things you normally lug around. Trying to take pictures on a bright, humid summer day with thirty or so pounds of gear dangling from your neck and shoulders can get pretty nasty, especially if you're not getting paid for the work. Leave all the gear you know you won't be using at home. When you arrive at your destination, with any luck the cameras and lenses will be supportable around your neck with little difficulty. Spare film can be tucked into pockets, film cans hung bandolier style, and filters and such can be taped to camera straps—in their holders, please.

For those who want it, several companies sell a thing called a photographer's vest, which offers tons of pocket space, light weight, and a great deal of utility. I've never used one, but friends who have love the things, even though they look almost asininely pretentious. And add some $25 to your equipment bill. Pockets are arranged so that you can sort things easily and efficiently, and most of the vests even have loops to hold your tripod. Sounds ideal, but for some reason I've just never managed to part with the money required. Ask someone who uses one, and you'll almost certainly get one for yourself.

Film can be somewhat more of a problem in hot weather than

in cold. While extreme cold might cause cracked film leaders and occasionally a cracked emulsion base, the problems brought about by heat are a bit more subtle, though just as bad. Color shifts and loss of film speed are the major difficulties. Certainly everyone by now knows not to carry film, or cameras, on the back shelf or in the glove box of a car during hot weather. Among other things, the camera lubricants may melt, leaving the metal unprotected. Apply the same rule to film and extra lenses. Keep all such stuff away from excess heat over extended periods of time—the interior of a car can reach well over 120 degrees just sitting in the sun on an 80-degree day! Use a cooler, with ice, if needed.

Best results will be obtained if you treat your camera as you would treat a child too young to be left on its own, and not hardy enough to stand being left in hot, enclosed spaces away from its parents. Of course, when the time comes, you'll have to punish the equipment to get some of the shots you want. The cameras will take that punishment if you don't punish them unnecessarily at other times. And you'll save repair costs and get photos that broken equipment would otherwise lose for you.

10.

Animal Photography

The type of action photography which requires the most patience and the smoothest technique is the picturing of animals, including birds, in motion. Pet photography, in and of itself, can be extremely difficult, but wildlife photography is a further extension of the problems to be faced when looking for good pictures.

Consider the pet. Classify this one as a feline, and we'll demonstrate with our eight-year-old calico cat Myfanwy. Ol' Myf is the friendliest cat in the world to her family, but she's not all that fond of most strangers. She's a very attractive animal, with her orange and black and white and tan coat. But she's nearly impossible to photograph in action for the simple reason that the instant I break out a camera, she trots over to see what the joke is, what's trying to hide behind that glass. She'll break off any activity to check out a camera! Extreme patience has been necessary over the past eight years or so to get any decent photos of Myf, and the good ones are still few in number.

The classic opposite also lives in our house. Loki is a black, altered—or ex—tomcat. He's all black, not a white hair anywhere, and shares with Myf the rather common feline phenomenon of one extra toe on each front foot. Loki won't interrupt anything for anybody unless he's begging for a head scratching and gets a better offer on the other side of the room. But. His velvety black coat makes for absolutely rotten photos! The soft fur just soaks up light, giving no shadows—how can you have a shadow on pure black (and this cat is not blue-black or any such mixture,

he's just black!). Details in his impressive musculature are almost always lost in naturally lighted indoor photos. Flash is essential, or outside sunlight of great brightness. Completely co-operative, but still a rotten subject for photographs.

Still, pet photographs are possible—in most cases, even easy. Cats, dogs, birds all play silly games no matter their ages, and we can snap away until the film or the budget runs out, getting a large number of printable shots per frame expended.

Generally, younger cats and kittens are easier to induce into action, but good, fresh catnip toys will usually inspire at least a few minutes' riotous play in all but the most infirm felines. Like all photographs which are taken at special times, it will pay you to spend some time selecting a background area. There's nothing great about pet photographs taken in front of a pile of children's toys or old newspapers! Try to select an uncluttered background, if at all possible. Of course, you may have to make do, for cats and other animals don't even think of such things, and their ideas of a proper place to play may differ considerably from yours.

With dogs, the photographer generally has an easier time. This is simply because dogs aren't born quite as contrary as cats, and are more often quite happy to participate in whatever activity in whatever area suits the picture taker. Not so cats. Their independence of mind makes them the most difficult of the usual home pets to photograph.

With any animal, props are a help. Dogs love to chase sticks, and the water-loving breeds make fine photos as they leap and cavort in the wet stuff. Two dogs pulling at a rope or a rag can make for some interesting shots, as can a dog jumping over a stick held at a reasonable height above the ground.

General dog photography can be accomplished with nearly any camera and lens combination, so there's no need to get fancy with long and short lenses. Just a normal lens on a moderately good camera, and you should get some fine shots.

Cats will offer many opportunities for the person with only a normal lens, and with only normal patience, but the photographer with an abnormal store of patience will win out most often. Again, props are handy. The catnip mouse is a standard, but I've found that cats can be tricked into playing with almost any item, even when thoroughly bored with the original toy. Simply

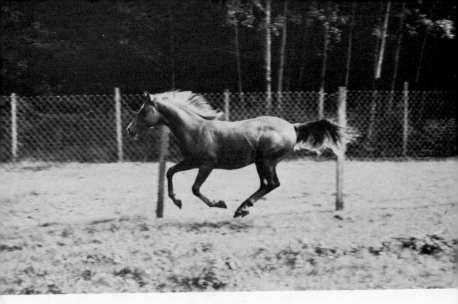

Figure 26

tie about three feet of cord from the mouse or whatever and then pull it about, flipping it around. Drives cats nuts!

Occasionally you'll run into an animal with odd tastes in fun. Myf, our calico, absolutely loves being swung about on a small rug. She picked up this taste when for some reason we were moving some small rugs around and just pulled them across the floor. On jumped Myf and the ride began. Eight years later, she'll keep it up until you collapse from spinning around with the rug. Look for these oddball tastes, for they will often form the easiest and most interesting photos.

Kittens can be fooled into doing absolutely silly things, and some of the craziest require little or no coercion. Ours have, for some reason, always been the type who loved to climb screen doors—and perch on the inch-wide top if the door was propped open. If they need help, play with them, watch their reactions to your actions. Do they chase? Do they sit and look puzzled? Are they frightened? Keep track of any pet reactions, whether cat, dog or whatever, and you'll have a better idea of how many of your shots will turn out.

For cats and dogs, where the action doesn't move up to eye level, the best photos are usually found down at the animal's level. Don't wear new clothes!

Horses make popular subjects for photographers, and make

reasonably easy subjects, too. After all, the horse is a large animal, with pretty well-defined muscles, ears, mane and so on, so there's plenty on which to focus. And there's a great deal of musculature to tauten when the horse is in action.

The very size of a horse presents the photographer with a major caution. Just a twitch from a horse's rump at the wrong time can do a fair-to-middling amount of damage to the human body. Simply climbing into a pasture with a strange horse, or group of strange horses, is not a smart way to proceed. Danger aside, in some areas of the country such tactics can also get you arrested for trespassing!

If you have friends who raise horses, fine. The Arabians pictured in this book are owned by a friend of ours. John virtually hand-raises his horses, to the point where they are more like large dogs than horses. Horses such as this offer the epitome in safety, but they'll still run right over you if you're not careful. Normally, I would recommend at least a 100mm, preferably a 135mm, lens for most horse photography. Staying outside pasture fences and shooting between the rails is also a good idea, and can easily be done if you have someone drive one or more toward you—not into the fence! For permission to do this type of photography, you've got the greatest come-on in the world. Offer the owner a couple of free prints and you're in. I've never met a horse owner, or a horse lover, who had enough pictures of his animals.

Animals in nature present problems, many of which the average person won't be interested in because of the need for heavy equipment expenditures. Still, with your trusty 35mm SLR, and the longest lens in your arsenal, you have a better-than-fair chance of bringing home bird and animal photos. In fact, with the present increase of drive-through zoos, with loose and wandering animals of all sorts, the chances are better than ever before. While it's unlikely that anyone in Hackensack or San Remo will see a lion make his kill at the local zoo, the photo opportunities at these drive-through zoos are great, though, as with all animal photography, patience is still needed (as are certain other precautions such as leaving the windows of your car *up* and not leaving the car unless park regulations so permit).

Shooting through the car window causes a certain amount of image distortion, but shooting through an open window at a feeding lion or wandering baboon can cause problems that no picture in the world is worth. For those times when shooting through glass is essential, the best way to operate is to place the front of the lens shade (or the front lens ring) against the glass as flatly as possible. Some loss in quality will result, but if you're careful about reflections the pictures should still be good. Usually, at least a 200mm lens will be needed to "move in" on your subject. Remember, too, to use a skylight (1A) filter on a lens that long.

Most general-action photography techniques work well for animals on the move. With the darting motions peculiar to many animals and birds, peak-action technique would seem to be ideal, but unfortunately it's almost worthless. There's seldom enough advance notice of where the action will end for you to pre-focus properly, though the use of hyperfocal distance can sometimes aid in the use of peak-action technique with wild animals. Even then, you'll lose a lot of shots because the animal turned in the opposite direction from the one you were expecting. Panning and patience in bird and animal photography will help to overcome this problem, though it will always be present.

A bird reacts so rapidly that it can often dart out of the image area just between the time your mirror slams up and your shutter opens! That's quick. It is also a problem, since such movements tend to produce poor photos of sky and little else. The easiest cure is simply to get far enough way so whatever sounds you make will diminish enough not to startle the bird into changing flight plans. Use of at least a 135mm lens, preferably even longer, will aid your bird picture-taking aims. Birds offer little opportunity for peak-action shots, but chances for using panning and other techniques abound.

Often bird photographs look just as good with all action frozen. (Our minds have come to realize that a bird stays suspended in air without wing movement—though if you ever spend a day watching soaring hawks you may wonder—so that the action is inherent in the elements of the bird and the sky.) It's possible to get all kinds of shots, from waterfowl landing (and taking off) to eagles, falcons, hawks, owls or whatever diving after their

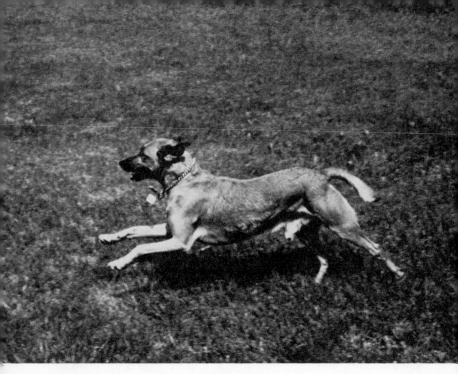

Figure 27

daily meals. Patience and some knowledge of the habits of birds of prey, plus a knowledge of the area surrounding your picture-taking spots, help a great deal.

Some other types of nature photos require even more knowledge, a fair amount of stealth, and nearly inhuman amounts of patience. To locate a raccoon isn't too hard, but to locate one during daylight is. Thus, you've got to locate and light the animal, and the odds are good that you won't be able to use your normal lens. If you get that close, any ol' boar raccoon is going to take off away from you. Thus, at the shortest, a 100mm or 135mm lens, fitted with electronic flash and a flash focuser or sleeve, are needed. One other way can be used, but you must buy and risk some gear. Locate a feeding area, or bait an area where the animal you want to photograph is known to hang out. Then place a flash unit or two off to the sides, adjusted properly for distance and all the other variables, using a long PC cord on one flash unit to allow the camera to be set back some feet (if you plan to hang around and operate the camera, get as far away as pos-

sible). Use a Spiratone flash slave to fire the second flash unit. Using a remote firing device and a motor drive set on single shot, you can often pick up a good series of shots this way. But the drive and extra lights can be very expensive. With just the extra lights, a moderate-length lens, the flash slave unit, and a long PC cord, the price is more reasonable.

Animal photography is a great deal of fun, but it's also a lot of work if you want good results. And the wilder the animals are, the more work is involved. Actual physical labor isn't all that strenuous, since it seldom involves more than a hike of a few miles. But mental work and the strain on your patience can be considerable. Without the proper planning, the whole attempt will be a waste of time. With a bit of planning, a lot of patience, and some luck, you can almost count on having some fine animal photographs to add to your collection.

11.

Children on the Move

Photographing children can be one of the most rewarding or one of the most frustrating experiences a photographer can experience. Some of the results of action photography involving children are fine, while many never manage to capture the vitality of the original action, thus eliminating at least 50 per cent of your reason for taking the photograph in the first place.

Part of the problem lies in the nature of the action when small children are the subjects. They do not move as fast as do older children and adults, and their movement is often more erratic. Another part of the problem can lie in the psychology of the children themselves. Many children love to have their pictures taken, but at the same time, too much emphasis on the cuteness of the child may turn the child into a brat. When that happens, you might just as well forget pictures of that child for that day and spend some time examining your technique.

The first problem is the easiest to handle, since its basis is primarily technical, and technique and technology can come almost instantly to your aid. Simply use slower film, slower shutter speeds, or a combination of the two to regain the feel of speed. Change shooting angles so that arms and legs blur. Slip around and get enough shots so that you eventually catch arms and legs pumping, or a foot off the ground. Work and think, applying the panning techniques described earlier. Use the slowest possible shutter speeds consistent with sharp results.

If you are able to catch the children at play, you'll often find such problems disappear of themselves. At play, whether riding bicycles or sliding down a ramp, the child picks up speed quickly, leaving adults dragging behind. Swings are excellent. Expressions of joy, the suspension of the swing at the ends of its arc, the framing possible from many angles, the panning possibilities from the sides, all add up to dozens, even hundreds, of photo opportunities. And most of the time the child will be unaware or uncaring about your presence and the presence of your camera.

As long as children are not overposed, stultified, made to feel as if they are chore-producing little pests, great results are possible. But let their attention lock onto the camera and you'll rapidly find yourself in the unenviable position of the child photographer, a person who does nothing but take pictures of children all day, day after day. A very few are good at this, creating unusual situations, producing interesting and striking photographs. Most aren't. One or more bored, smiling children lined up against a sheet of seamless paper, crouching cutely for the glass eye of the camera. Nothing more than a record for doting parents.

Action photography of children can be much more. A record for doting parents still, but also a replication of the joy and energy the young bring to every activity. Here your technical expertise may not matter as much as your perceived personality. If you don't really care for children and show that with a continual growl or snarl, they'll most likely respond either in kind or not at all. If you don't particularly care for children, but can respond with interest to some of their affairs and avoid the parts you don't care for, you'll usually find an interested child, willing to be directed—gently—or to play until both your tongues drag and you get several shots you'll love. Like any other generalization, the above will work much of the time and just about the time you are sure it's perfect, it will fail completely. So use judgment.

Children's activities are broad, so broad that these days you have to make use of almost all of the techniques described in other chapters and sections. No special equipment is needed to shoot photos of children, but there's a lot to be done with special gear when they get involved in some sports. Shooting baseball of any kind is a waste of film when only a normal lens is used, and Little

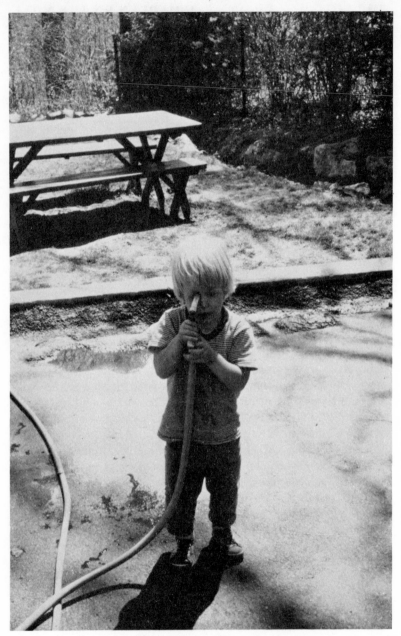

Figure 28

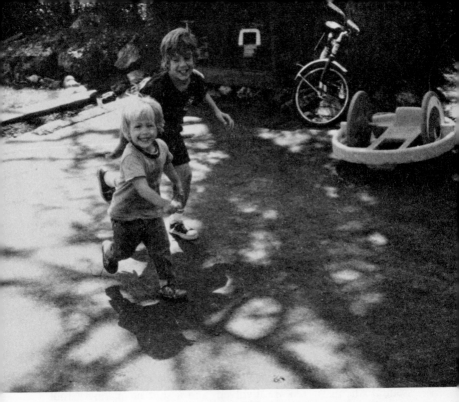

Figure 29

League games provide the same spread-out action as do the Big League games, though the fields and players are a bit smaller than the average Big Leaguer.

In unsupervised play you can easily move right in on swings and slides. For impromptu foot races that children are wont to run, you'll probably want a 135mm or a zoom lens, since it's often difficult or impossible to predict just where one of these sprints will start or end. For the sandlot football games, a 100mm or 135mm tele is handy, though not by any means essential. With these informal games, it's much easier to get in close enough to frame the action than it is at a big-time college or pro game. Just make sure a child doesn't ram into you and your gear and get hurt!

Possibly the most rewarding photographs of children in action are those that clearly show the face, the joy found in those care-free years when the happy child has fewer worries than he'll

have for the rest of his life. When shooting primarily to capture faces in action, you can try to blur legs or torso to see what the results will be—a lot, of course, depends on the activity, since it must be pretty frenetic to allow only the head motion to be panned. Preparation for action can show many moods, and in these slower shots it's generally advisable to do as most portrait photographers do: focus on the eye(s).

Most adults will stand still for a picture—physically, that is— even when they don't particularly want to be photographed. Most children won't. They haven't yet acquired the full veneer of civilization that life drops on all of us eventually, so their answers are more likely to be bluntly honest. They'll run away, pout, hide, refuse, mug, and just generally make any type of picture taking impossible or difficult. Most of the time, though, they'll love it. When you meet a difficult child and want to take some pictures, the best bet is to wait. Try and be around when the child is in a better, more compliant mood. Wheedling, baby talk, threats, and other forms of adult persuasion will seldom do more than make the photographer (or the child's parents) feel asinine or monstrous. If you and your camera expect to record good scenes, patience is essential when children are involved, and a shot at making a fool of yourself doesn't help. Just be around. Be natural. Sooner or later the average child will accept you, and will allow you the opportunities you've been looking for.

Oh. Good luck. That helps too.

12.

The Variety of Sports

Certain techniques are more applicable to some sports than to others. Slow-speed panning, for instance, has a better chance of success with a miler than with a 200mph stock car ramming down the back straight at Daytona. Peak-action, or pendulum-effect, shots have a greater chance of success when used in a basketball game than in trying to catch the jump activity at a motocross race where the motorcyclist making the jump may be holding a forward speed of as much as 50mph! With that in mind, a look at a few of the action sports and their special features, including what is required in technique, knowledge, and special equipment, may help you to get a few more good pictures.

Motor sports break down into separate forms covering dozens of kinds of racing. Auto racing itself has so many forms it's impossible to accurately describe them all in a book on another subject, like this one. Certain forms are most popular and the most easily located and photographed. Activities such as drag racing, stock-car racing, short-track stocks and modifieds, along with sportsman classes, top the list. The varieties of "sports" car racing are probably next, though sports cars seem to have gone the way of the dodo, and are supplanted by roaring monsters of Can-Am and Grand Prix cars. All these racing activities have common points, but there are points where that common ground gets a bit slippery, too.

Drag racing is probably the single most available motor sport in most areas of the United States. The cars line up at the start. They jiggle and jockey a few feet back and forth, possibly do a few burnouts to warm up the tires. The engines rumble, the bodies shake, as the drivers start expecting the Christmas tree (named for its red and green lights in vertical rows) to change to all green. The thunder from the engines increases. Green! Tires spin, engines howl. Clouds of smoke are flung high in the air, a combination of burning rubber and burned nitromethane fuels. Six or seven seconds later, for funny cars and top fuel dragsters (possibly as little as 5½ seconds for the top cars), the cars will have blasted through the lights at the end of the trap.

Depending a great deal on your location, you can get some fine action shots here. If possible, you should try to talk the promoter or his agent into letting you get as close as possible without excessive danger. You should observe the runs for as long as possible before trying to come up with any "keeper" photographs.

Starting-line shots can be taken from behind, to the side or out in front (not on the track!) of the cars. Shots from behind will get the smoke streaming up from the tires, and may also show flames shooting from the exhaust—more likely to show up at a night race. Up-track shots can show the cars getting off the line together, or one car getting a jump and "putting a hole shot" on the other, as can sideline shots. Again, the extremely fast action of this type of racing requires a quick trigger finger and precise anticipation. You don't have much time to daydream once the cars stage. With no motor drive, the best you can hope for in a full run is about three shots, and I'd figure on two for sure. A six-second run, with a 3.5-frame-per-second motor drive will give shots of the whole length of the strip (with the proper lenses), and makes for a spectacular mural if the cars are burning out all the way (most long burnouts are done on demonstration runs or by accident). Of course, with a motor drive, you'd better figure on one 36-exposure roll of film for every two runs. If anything spectacular happens, you'll almost certainly have it, but you'd better hope there are some great shots in all you've taken. If a magazine editor doesn't buy, those processing costs are gonna be unreal!

Recommendations: Study the action. See where the particular drivers, at this particular strip, seem to put on the best show. Arrange to be as near that point as possible—staying safely behind guard rails. Use a high-speed film such as High Speed Ektachrome (ASA 160) or Tri-X-Pan. Use a high shutter speed with the faster classes. Trying to pan these 200mph dragsters at 1/60 second is difficult. It can be done at 1/60, and even 1/15, but it's difficult, though the resulting photos are often excellent. Start by panning at 1/250 or even 1/500, setting your lens openings for as much depth of field as possible at those shutter speeds. You can't always tell which lane will provide the most action, so the best idea is to pre-focus between lanes and then try to retain enough depth of field to cover both. As you gain more surety of technique, you'll be able to adjust the pre-focus on the instant, but such dexterity comes only with practice, so start between lanes. If possible, use a 200mm lens, or a 70–220mm zoom to follow the action. Longer lenses are unwieldy, and shorter lenses won't give you as good coverage of the entire length of the track. The above covers only basics. Work from there on your own. Try a wide-angle lens for some of the action, and get some pit shots to round out your photo story.

Stock-car action can be very difficult for the average spectator to shoot, simply because you may have a hard time getting to the best spot for good photos. The infield is almost always the best place, but not all stock-car courses allow spectators in the infield. If possible, though, that's the place to be. Stand shots limit you to head-on and high-angle side shots from the outside of the track. The longest lens you can hand-hold will be barely long enough (300mm) unless you've paid a fortune for trackside seats. Start action can be great, and good shots of straight action can be taken if you look for seats 100 or 200 feet down the straight from the start/finish line (or find your way over there before the start and don't get chased out by guards or spectators who refuse to allow you to block their view). Still, you'll be up pretty high, stuck with that angle for all your shots.

If the course does allow you into the infield, you're in much better shape. You probably still won't be able to get into the pits —in some races, not only for standard cars but also for motorcycles and Grand Prix cars, even working photographers get hassled by track personnel who feel a weekend with a badge makes them John Wayne and Audie Murphy rolled into one bean-brained and beer-bellied package. In fact, one of the incidents the late Jim Clark, many times World Driving Champion, was known for was popping a cop in the head because he hassled Clark during a race practice, when Clark was looking for an observation spot to watch some other drivers practice! If World Champion Drivers can't get into their own areas, or into special spectator areas, bet on your having trouble doing so. But it makes for some great shots when you can get in. Low-level shots, taken lying or kneeling are a great deal more spectacular than are shots of car rooftops taken from the stands. You may still be on a round or oval track, with little obvious difference between corners, but there is plenty of difference up in those turns from a driver's point of view. Look for the different results. One turn will cause some drivers to go all loose, sliding up near the wall, while others will see them coming in low and hard, not getting up near the wall until they're pretty well straightened out and heading onto the straight. Such details can make a lot of difference in photo quality.

Recommendations: Observe a race or two before getting serious about taking pictures. The same camera/lens setup as for drag racing, with the admonition to move around more, to see what's happening on the different corners, on the different straights, and in the pits as the cars roll in to get gassed, worked on, have the tires changed and so on. Pit-action shots can add to the drama of a photo story on racing. Again, picking your spots, panning at high and low shutter speeds, pre-focusing and imagination are your best allies. So is fast film; but often, if the race starts shortly after noon, you can get some great pan shots on slower film, all the way down to Kodachrome 25. Look to your wide-angle lens for pit shots, for shots of infield spectators, of stand onlookers and so on. Wide angles under 28mm are handy when

trying to shoot the car carrying the winning crew into victory lane, because you'll be jostled, and most likely shoved up too close to use a tele or normal lens.

Motorcycle road racing and sports-car racing have many things in common, not the least of which is that the races are usually run on the same courses. In the United States and Europe, motor-cycle racers get the tracks when the cars aren't using them, making for some novel problems for the motorcyclists when the cars break up the road surface and when heavy-duty Armco barriers are installed to keep cars from crashing into even more hazardous areas. Protective barriers for auto racers are often death traps for motorcycle riders who are not protected by a frame and metal body. A knowledge of what's difficult for one type of racer, however, will at least partly transfer to another. A slow-speed corner for a car is also going to be a slow-speed corner for a bike. A tight track is usually tighter for cars than for bikes. Car speeds are usually a bit higher, but motorcycles appear to be moving faster in the curves. Sometimes riders will lean over so far they actually grind away the toes of their boots. Certain types of road surface cause bigger problems for bikes, too. Rough, bumpy, sandy surfaces are handled more easily with four wheels under you. Seldom will a car hit a large bump and leave the ground long enough to over-rev the engine so that it blows when the rear wheels make contact with the ground. Yet Gary Nixon, one of the top motorcycle racers in the world, hit a bump that lifted the rear wheel of his bike at a recent Daytona 200. When the wheel recontacted the ground, Nixon was sliding along on the pavement at about 125mph. He wasn't badly injured, but the motorcycle was a total loss and his day's racing—and his lead—was over. Such accidents offer spectacular shots for the photog-rapher, and course knowledge is a large part of the reason anyone gets such shots. Of course, there's also an element of luck involved, but knowing a course well can pay off for the photographer as well as the racer.

Other bits of data come in handy too. When you learn that the race course invariably becomes slippery later in the race, you've got a start on catching good photos. The buildup of engine oil

and rubber on the curves is the reason. On very hot days, the course may start out slipperier than usual, since the paving may be in a semiliquid state in some places.

Recommendations: A long lens, 200mm, for most of your road-racing action shots, with a shorter lens, 100mm or 105mm, for shots of more than one vehicle at moderate ranges. A motor drive can be handy to catch accidents and a few other sequences, but otherwise it is not essential. Find both fast and slow corners to photograph. Add some panned shots of the racers zipping along the straights against a background of bleachers and signs. Try different angles for motorcycles and for open-cockpit shots of cars. Getting up high and shooting the rider or driver as he struggles with his overpowered mechanical monster can provide some interesting effects, especially if you pan and the road under the wheels comes through as a blur. Low-angle shots, though more common, are equally effective. The inside of curves usually supplies the better shots, and is safer than hanging around on the outside, which is where most racers run off the course when they lose control. If the race runs into darkness—only on special endurance runs for motorcycles, which you probably won't even hear about unless you have friends in the factory—try long-exposure tripod-braced panning shots, or let the cars blur and the background stand out as the lights whoosh by. Again, use your wide angle for people and pit shots. Move around and change angles frequently so that your shots don't develop a dull sameness, with only the rider number and color of machine as variation.

Other types of motorcycle racing need somewhat different techniques than do car races run on similar tracks. Mile and half-mile motorcycle racing are done on flat oval dirt or clay tracks. Here again, infield shoots are the best, but not always possible, unless you manage to work some sort of "in" with the promoter. Try, because you'll get more and better photos. A look at mile flat-track will suffice, as the half-miles are much the same, with slightly slower speeds (from the photographer's point of view).

At the start, there will be riders lined up according to heat or qualifying run times. The thunder and action of the start seem to come through well in pictures shot from an angle slightly to the side and front. Action in the first turn is hectic with everyone wanting first place and the fast lane. As they come out of the

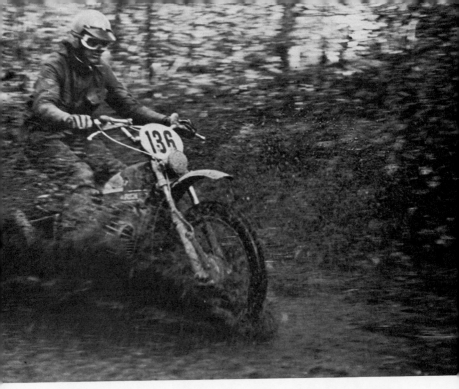

Figure 30. Canon F1, 50mm lens, 1/60 at ƒ/4. High Speed Ektachrome pushed to ASA 400 (converted to black and white). PHOTO BY THE AUTHOR.

second turn, the riders will slide back on the seats and crouch down to cut wind resistance. Down the back straight, speeds will reach about 135mph as the riders blast by, one hand locking the throttle open and the other gripping the left fork downtube. As the corner approaches, the rider will suddenly sit up, sliding forward on the seat. At this point several techniques are used to break the rear wheel loose. As that wheel starts its slide, the rider gives a slight cock to the front wheel and rams his foot down (some, however, slide with both feet up!). As the foot, protected by a steel shoe, contacts the course, the motorcycle will be in a controlled slide at about 100mph, with the rider able to maintain a line to pass, change a line to allow another rider by, and generally stay off the ground. All of this with a wood or concrete wall on the outside of the curve, and a few hay bales at its base. Think about it.

The shots of riders setting up, sliding into and through, and powering out of these turns are spine-tingling. As you pan along, you'll be able to pick up the essence of racing, the tension and the joy in the same face all at once.

Recommendations: Again, learn the track. Use a moderate lens from the infield, say a 135mm tele or a zoom. Motors are great here, as you can get the rider from the start of a curve right on through with little or no change of focus.

Apply the above recommendations to other types of motor racing. Motorcycle speedway racing can be shot in much the same way that flat track is covered. Motocross can be shot very much like road racing, with somewhat shorter lenses, since it's usually possible to get a lot closer to the action. Various kinds of rallies and such for cars and motorcycles can present excellent photo opportunities. Ice racing, both for cars and bikes, is a great opportunity to develop both winter and action shooting skills. Most ice races are rather informal affairs and are run more or less on a locally approved schedule and basis which tends to allow greater freedom of access to the best shooting spots.

Baseball, for years the premier American sport, is watched by many millions of people in one form or another. For the action photographer certain problems are presented by the generally wide spread of the field and the possibility of action happening at almost any corner at any time during the game.

While standard shots of the pitcher, catcher and batter are relatively simple to take with the appropriate lens and film combination, getting good shots of field action requires very quick reflexes and a fair knowledge of the overall tactics of the game. Generally, for games where you cannot get close to the sidelines, you'll need the longest lens available in your gadget bag. Figure on 200mm for most shots, and 300mm for some.

If the game is Little League, Pony League, or some sandlot game, you should be able to get close enough to use your 200mm or even a 135mm for nearly everything. Lenses shorter than 135mm will not cover the field well enough to give you good shots of outfield, infield and batting action from one or two fairly close-together positions.

Recommendations: Use the longest lens you have, and don't expect to get by with anything less than 135mm telephotos. Adapt the film to the game, using High Speed Ektachrome or something equally fast for dim days, and an ASA 64-to-100 film for most other days. (One advantage of baseball photography is the fact that games are often stopped or postponed because of rain, which offers the photographer better chances for good pictures, the weather being usually quite bright when a game is played, since baseball is mostly a daytime summer activity.) Night games pose a slightly different problem. You'll need a high-speed black-and-white film or a color film adjusted for tungsten lighting. If the lighting isn't tungsten, you have to be able to get close enough to use fill-in flash. Watch the action and try to follow the strategy, so that you're not expecting third-base action when all reasonable possibilities point to first-base action or steal from first to second. Learn to aim and fire quickly. Hyperfocal distance can be of great help here, keeping most of the field in sharp detail when the pictures are processed.

Basketball: Another action-filled sport, and one which the amateur can cover quite well, assuming he stays pretty much away from the pros. Actually, in basketball you may well find easier access to good shooting areas than with most other pro sports. A knowledge of people and places can be a big help, as can having some good action photos for the team's PR man and an offer to supply him with a few prints. You won't make the team photographer happy, but . . .

In general, local high school and college basketball games offer as good photo opportunities as the pro games, with little chance of your getting booted out for being in the wrong place. Of course, if U.C.L.A. and Notre Dame are the college teams, forget it. Such teams draw bigger, wilder crowds than most of the pros do, and you'll have to be very well connected to get permission to run about and shoot. Permission for most action photography here can be gotten from the home-team coach or whomever he designates.

Recommendations: No flash should be needed in most modern gyms, though FP bulbs can be handy at times. If you use elec-

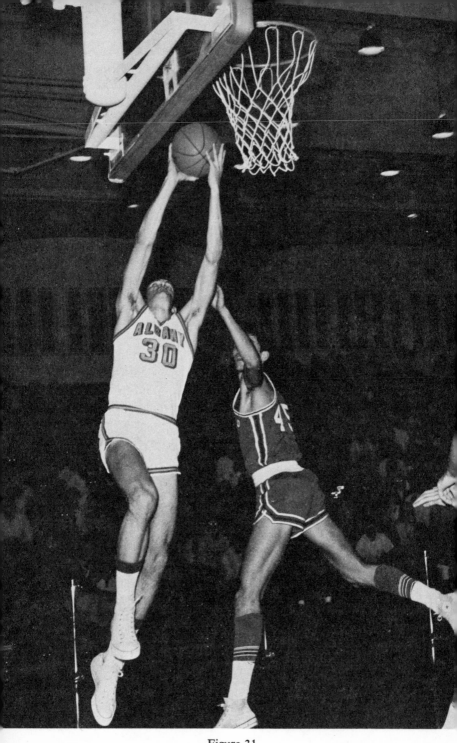

Figure 31

tronic flash, use a film of ASA 125 or less. A moderate tele, 135mm or less, should do fine unless you're stuck at the top of the stands. For basketball, the pendulum effect (peak action) will catch those jump and hook shots right at the high points. Panning will help as the ball is brought up and down the court. No motor drive is needed. If you're not using flash, black and white is the easiest film to use, and use the fastest film (ASA 400). For no-flash color find out whether the gym has incandescent or tungsten lighting, and use the appropriate indoor film. If the lighting is fluorescent, you've got problems if you should want to shoot non-flash color. It's almost impossible to filter correctly for fluorescent light, and it is impossible if you don't know the exact type of bulb in use. When all the needed filters are added up, you've lost almost all the speed advantage of your fast film. Almost best bet: Shoot GAF 500 and accept slightly off results. Really best bet: Shoot only black and white.

Recommendations: 100 to 135mm lens; fast film; no flash unless essential; panning, peak-action shots and pre-focusing will catch the action. Watch your depth of field. Learn how the action flows for the teams you're watching and you'll pick up some fine shots.

Football is possibly the easiest action sport to record on film. It's played outdoors, usually in reasonably bright daylight or under very bright stadium lighting. The action is confined to a relatively small area, allowing reasonably accurate pre-focusing and few missed shots. Yet there's plenty happening on each play. You can either follow the ball or get some action in the pit, as the linemen hammer and elbow each other trying to move mountains of flesh.

Football will certainly be a lot easier to photograph if you learn a bit about the tactics of the game. In-depth tactical knowledge isn't really required unless you've got a penchant for knowing the call signals for each team's various plays. If you've seldom or never paid much attention, good photographs are more likely if you happen to know that only a very daring quarterback will pass on third and ten with the ball on his own ten-yard line. Learn as much as possible about each team's execution. What's the likelihood of a quarterback's passing on third and three? A lot will depend on the strength of the backfield. With O. J. Simpson and

no good receivers, the pass is very unlikely. With Larry Csonka and Paul Warfield, the play could go either way. Watching the line can sometimes help, though not with the really good teams. Sometimes a certain team member is sent in in pass situations and removed for runs, and vice versa. With intuition based on some tactical knowledge, your percentage of correct guesses ought to approach 60 per cent.

Recommendations: 135mm lens if you can get to the sidelines and end zones; 200mm for end zone and stand work. Motor or no motor. Move about, try for different angles. Shoot while standing, kneeling, lying down. Try to follow the ball on passes. Proper pre-focusing on such shots might just get you a picture showing one of those great over-the-shoulder catches. Experiment as you wish. Film speed should be suited to the weather: medium for bright days; high for cloudy days and under stadium lights. If you're shooting pro games at night, check with a TV cameraman for the color temperature of the field lights, then use the correct artificial-light film.

As usual, local school and semi-pro events are easier to photograph. It's very unlikely you'll be bounced from the sidelines as your son trots across the goal line, but the odds are good you'll be moved out of the way at a pro game unless you look very much like an official photographer for someone or have a press pass. Don't expect to get a press pass easily either. Just getting tickets can be nearly impossible! Semi-pro games are an entirely different matter. Your local semi-pro manager might be perfectly willing to trade off a pass for some good shots of his team in action, and you might be able to include locker-room access in the deal. It's certainly worth a try anyway.

Hockey is a difficult game to photograph. Period. The lights are usually a bit too bright for flash work, and the smaller arenas may be a bit dim for nonflash work, leaving you in a bit of a quandary. Action is often so frantic that FP bulbs are nearly useless, leaving you with a chance to find out if that three-second recycling claim for your expensive electronic flash is accurate (such a claim is more likely to be accurate if the flash uses a separate power pack with several large batteries). Thyristor auto flash

Figure 32

PHOTO COURTESY OF N.Y. JETS

Figure 33

PHOTO COURTESY OF N.Y. JETS

units are great for indoor sports in limited areas, even areas as large as a hockey rink or basketball court. If possible, though, shoot over the protecting glass or plastic, not through it. If you're in a front row, this is simple, though hanging over the glass too often may bug the other spectators. Don't hang any more of yourself over that glass than is needed, because hockey pucks can smart when they hit, and can do real damage should one bounce off your head. If you're up front, a short tele (100mm or 105mm) will do very well, but shooting from back in the stands can require lenses up to 200mm.

Recommendations: If high seats and long lenses don't seem to coincide very well with your talents, get a seat as close to the glass as possible. When the time to shoot comes, move up the aisle to the glass and raise the camera above it. If shooting through the glass seems necessary, get as close as you can, preferably with the front of the camera right on the glass to cut down on unwanted reflections. Best bet is to shoot over the glass, though. Lens: 85mm to 135mm for close-to-glass shooting, 200mm for shooting from the stands. Most hockey rinks are lighted well enough so that you won't need flash, but go electronic if you do. No motor here. Most zoom lenses will be a bit short on lens speed for this type of action, though some of the more expensive ones are fast enough. Use fast film, either black and white or indoor color.

Look for the action at the blue lines, in the crease across the goal mouth, and generally follow the puck. Keep an eye out for action in the corners, since that's where about 90 per cent of hockey's fights seem to start. Also look to face-offs for action.

If you shoot through the glass, take many extra shots, as you'll lose a lot from image deterioration and from reflections.

Swimming and **diving** are two interesting sports, one of which offers quite spectacular photo opportunities. Because so many of the meets are held in indoor pools, though, lighting and film choice sort of floats along with the competitors.

For indoor competition, check to see what sort of lighting is to be used, and then select a film which will handle the light (for color, under normal incandescent light, try High Speed Ektachrome Type B [ASA 125]). If flash is necessary, use the slowest possible film, whether color or black and white, to provide less chance for ambient light ghosts to ruin the pictures.

Figure 34
PHOTO COURTESY OF JERRY LIEBMAN

Recommendations: For swimming, flash will probably be needed. Use film no faster than ASA 80, if at all possible, when flash is used. Listen for the lanes of the favorites, and try to set your depth of field or hyperfocal distance so that the favorite is right in the center. For diving, if you're lucky, the event will be held outdoors. Use a 135mm lens (if you can get that close to the competition), and try to catch each diver just taking off, in mid-acrobatics and during water entry. A motor drive helps here, but isn't essential if you've practiced enough to be quick. Film should be fast for outdoors (which is where most 10-meter diving will be held), slower for indoors (which is where many springboard diving meets take place).

Tennis is becoming a very popular game to watch, with photo possibilities quite good for the alert photographer. Whether a singles or doubles match, there will always be a lot of movement from side to side, though the movement in doubles is a bit more

constrained, and quite a bit of movement from the front to the back of the court. Look for returns and serves. Try to catch the power in the forearm as the player lunges to hit the ball.

Tennis is played for the most part like baseball—in good weather and outdoors—so that photo opportunities are enhanced. Depending on the caliber of the match, you'll need only a moderate-length lens, though a zoom of middle length would be quite good, allowing you to frame both ends of the court at about the same image size.

For pro matches, most of your shots will have to come from the stands, but for less formal games you should be able to get down to court level. That court by the way is a good thing for photographers, since the action is pretty much circumscribed in a small area, making the use of pre-focusing and standard depth of field quite simple.

Recommendations: Use a middle-range film for most conditions. Your lens should be 135mm or longer (depending on how close you're able to move). Pre-focus. Don't try to pan, as the direction changes in this sport can be ferocious; the same advice holds for peak-of-action attempts. While these attempts are sometimes successful, the odds are against them. Try to use a shutter speed fast enough to freeze the action, leaving hands and rackets to blur as they will (probably 1/250 second).

Track and field offers so much varied activity it's hard to know where to start. Basically, you'll need an interest in many of the contests to get good shots at track-and-field meets. You'll develop the ability to catch a shotputter at the instant he lunges across his circle and explodes to toss his 16-pound ball, but you'll find that different skills are helpful when you go to shoot the pole vaulter at the peak of his jump, as he either makes it or knocks the crossbar off the uprights. Or to get a miler as he breaks a tape, you'll need another technique to catch the outthrust chest, the expression of joyful anguish on his face.

Look for the special, small details which might make your photos more interesting. Though this is important in any type of photography, and in all action photography, it's of extreme importance when there's no obvious machine hurtling by at over

100mph to add to the visual interest and excitement. Catch the miler's arms as they fly into the air at the tape. Wait for the release of the hands as a gymnast starts a move on the parallel bars. Get the little things, show the stress of the competitor, make sure there's human interest, and the pictures will have life added to their movement. Often times, if you get the little things, the rest of the picture will take care of itself. Getting a pole vaulter as he just releases his pole and begins to clear the cross-bar—or smacks into it—tells a lot. Getting a close-up of his face with no sign of the related activity can be a wasted shot. Signs of strain can add to an action photo, but seldom should that be all there is in a photo.

Pole vaulters are easy subjects for the pendulum effect. As the vaulter releases the pole, his motion in one direction almost stops, while his motion in another direction has yet to start. A speed of 1/60 second should give good blur to the parts of his body still in motion. At 1/125 second, the muscle outline will be greater and the blur less. At local meets, you should be able to move in to the base of the uprights or very near to them, which allows fine positioning for shooting up into the vault after getting a shot of the vaulter coming almost head-on into the jump area. Watch all of the events, looking for the instant in each event which seems to you to best typify its action, the explosiveness or grace of that particular contest. Then work to catch that moment.

Recommendations: Lens length is highly variable here, depending on just how close you can, or wish to, get. Often, if you can arrange to be down amidst the events, a normal lens or 85mm tele will be perfect. If no flash is used, try a fast film, making sure that it's matched to the type of lighting if you're using color. Motor drives can give some interesting effects at track-and-field meets, as you follow, for example, the pole vaulter from takeoff to landing. No motor drive can replace the practiced eye for catching the absolute peak of action. In some events, a wide-angle lens will give good results and special effects, but it's best that you make that judgment after trying for special effects a few times with both long and short lenses.

At almost all track-and-field meets, several events will be going on at once. Locate those which seem to have the best possibilities

for you and fire away. Great photo possibilities are there if you can catch them.

Regional sports abound all over the United States, and the regions are sometimes quite huge. Consider skiing. Millions of participants. A long season starting in the high mountains of the West, where snow comes early and heavy. It then moves from coast to coast as the North is covered with a white blanket. Sailing is another sport that is regional because certain areas of the country don't have bodies of water suitable for this type of boating. Of course, there are always the diehards who stick sails on a wheeled boat and run across the desert sands. Rodeo is breaking away from its almost totally western image to cover much of the country, but the main impetus is still in the old cattle-raising country of the West. Karate and the other martial arts tend to be confined (as a sport, not as a defensive technique for modern city dwellers) to small groups who argue vehemently over whose rules are most valid and whose techniques are most deadly. Kung Fu may be faster than a speeding bullet on television and in the movies, but don't try it on your local mugger(s). A .45 makes a nasty hole!

All these sports, and many more, offer chances for action photography. In general, photo tips from other sports can be adapted. Rodeo, for instance, doesn't allow observers into the arena (and unless you've got a thing for being trampled, you don't really want to get in there), but neither does hockey. In many senses, rodeo is by far the easier of the two sports to photograph. Generally, rodeo action will take place outdoors, and there's no glass to shoot through. A 135mm or 200mm lens can get you right up on the gyrating horse, letting you catch every muscle outline of the animal, the tension in the cowboy's gloved hand and bare forearm, the frenzy in the movements of the horse. Too, rodeo animals come out of predesignated chutes, allowing you to prefocus accurately and almost assuring you of good pictures if your reflexes are average or a bit better.

Skiing turns in some of the most spectacular photos anyone can ever want. The colorful clothing and bright snow, under bright sun, offer easy shooting and hard-to-miss chances. With Ektachrome X set at $f/16$ and $1/125$, there's little chance of missing

any action, because your focus ranges from about 16 feet to infinity with a 50mm lens (which is all you need for ski photography, since it's almost always possible to get very close to the action). Remember to allow for extreme brightness of sun on cloudless days with snow-covered slopes, and you're in fine shape. A winterized camera and slow movement of the film, transport and rewind, will also keep problems down.

Surfing requires long lenses, often tripod-mounted and over 300mm. Some pretty good shots can result, but after a time everything starts to look alike to non-aficionados. If you like surfing, try at least a 200mm lens, moderate-speed film and allow for a bit less exposure over the water on bright days—one to two stops should do it. Shutter speed shouldn't drop under 1/125 second. Pre-focusing can help if you can do it over water. Wave movement tends to make it difficult, but then, most of the shots will probably be shot at infinity settings, so focus isn't all that big a problem.

Sailing offers a great many opportunities for the action photographer. Some good shots can be taken from shore, catching the boats as they heel over into the wind, picturing the crew activity as preparations are made for a fast tack or as sails are changed, etc. Even more can be shot from another boat. You can get in close enough to catch the straining crew members leaning— hiking—way out over the side, trying to gain as much speed as possible without capsizing. Fluttering sails as the wind drops and rises, the sudden departures from plan that ruin even the best schemes and bring dismay to the skipper's heart—and face. Again, make allowances for light over water, and use a skylight filter to get rid of any excess blue light. The shortest viable lens would be about 100mm, with on-shore stuff running up to and past 300mm with a tripod to prevent shaking. Moderate-speed film for bright days. Fast stuff for those interesting cloudy days when the wind comes in gusts.

Motorboating and motorboat racing offer more spills and thrills than does sailing. I'm not sure the resulting photos are any better, though many are more frightening. Usually (and disregarding the ocean racers) this type of racing is done on some sort of closed course which allows you to get in pretty close in another

boat for good shots with only a moderate telephoto lens. Just don't allow your boat to drift in front of a speeding hydroplane! Either use a good anchor, or have another person controlling the boat while you take photos. Lenses from 100mm up, moderate-to-fast film. Watch several races first to get the feel of things. One point: In any sort of motorboat, do not brace the camera against the boat when the engine is running. Engine vibration will transfer itself to the film and louse up your pictures!

Our apologies for not covering every sport, and possibly missing your favorite. Still, the tips scattered throughout can be applied to most other sports as well as those covered here. To make that job easier, whether the sport you love is soccer or flagpole sitting, here's a recount on the basic rules of sports and action photography.

Shutter speed is the prime factor in action photography. Too fast a shutter speed "freezes" action so that there is no apparent motion in the resulting photograph. Too slow a shutter speed leaves you witih impressionistic blurs. A proper shutter speed will leave in enough blur to present a feeling of tension while still presenting a recognizable photograph of the subject.

Pre-focus (or zone focus) allows you to be ready, to have one major operation already done, when the action arrives in your sector. Simply focus the camera on the approximate spot you expect your subject to pass through, then pan and click when the subject arrives. In most cases, depth of field will take care of any minor misses. When it won't, pre-focusing still has done most of the work for you, allowing you to move the focus ring only a millimeter or so to make things right.

Panning is simply the process of following the subject with the lens, clicking off the shot at a pre-selected point (if pre-selection was possible) and then following through. Because slow shutter speeds are often used, this is one of the more difficult action-photography techniques and requires some practice—all of these techniques will work more smoothly if you practice before you try to get good results. Reading about procedures only implants the ideas in your head. Practice will implant the skills in your hands, which is where they must be to turn out good photographs for you. Speeds as low as 1/15 second can be used for panning, and panning with very long lenses (200mm and up) should be done with a tripod.

Peak action is simply that. You can use a relatively slow shutter speed, say 1/60 second, to catch action as it reaches a peak and the pendulum effect takes over. The action must stop before action in another direction can start, and that's the peak you're looking for. This is probably the single most difficult action-photo technique and requires practice, forethought, and a knowledge of the activity taking place. Works, though.

Blurring action is easy. It's often done by mistake, by accidental jiggling of the camera during panning. Purposeful jiggling of the camera presents you with blurred action just like what you'd been getting in your early practice sessions. If you like such photos, fine. Keep them. More interesting blurred action can be accomplished by letting the subject pass in front of the lens while the camera is held steady. Background is sharp, while the subject passing by is a long blur. Low shutter speeds are best for this, and the best results come at night, shooting lighted vehicles with time exposures, which also requires a tripod.

Flash can be used as fill-in light or as a primary light source. As a fill-in light, flash allows the use of slower, finer-grained films during dim light situations, and as a primary light source, of course, it allows you to get shots where otherwise you would have had no chance. Electronic flash is the quickest, with most good units recycling in ten seconds or less, and is actually cheaper in the long run. It does present a ghost-image problem with focal-plane shutters in cases where the shutter synchs only at 1/45 or 1/60 of a second, and the flash fires in 1/1000 second. Too much ambient light will cause after-images to appear as ghostly presences implanted on film during the time the shutter is open after the flash has fired. In this kind of situation, focal-plane flashbulbs are best, since they will synch with the shutter at all speeds where the electronic flash doesn't. Most modern action photography can be done without flash, but it's often useful and sometimes essential.